Drawing and Painting with
Water Soluble Media

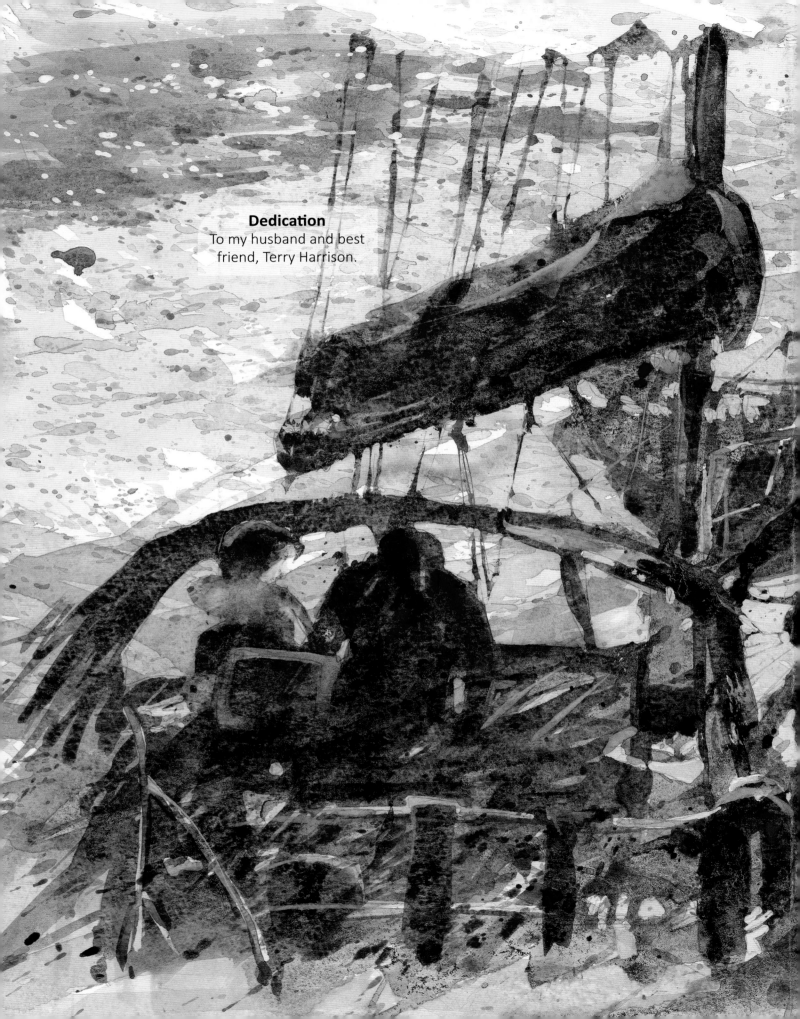

Dedication
To my husband and best
friend, Terry Harrison.

Drawing and Painting with **Water Soluble Media**

Fiona Peart

SEARCH PRESS

First published in 2014

Search Press Limited
Wellwood, North Farm Road,
Tunbridge Wells, Kent TN2 3DR

Text copyright © Fiona Peart, 2014

Photographs by Paul Bricknell at
Search Press Studios

Photographs and design copyright ©
Search Press Ltd, 2014

ISBN: 978-1-84448-953-4

The Publishers and author can accept no
responsibility for any consequences arising from
the information, advice or instructions given in
this publication.

Suppliers
If you have any difficulty obtaining any of the
materials and equipment mentioned in this book,
please visit the Search Press website:
www.searchpress.com

Publishers' notes
All the step-by-step photographs in this book
feature the author, Fiona Peart, demonstrating
her drawing and painting techniques. No
models have been used.

You are invited to visit the artist's website:
www.fionapeart.com

Printed in China

Acknowledgements

My thanks go to the team at Search Press for their
hard work behind the scenes.
A special thanks to my editor, Edd Ralph, for putting
it all together, to Juan Hayward for his creative page
layouts, and to photographer Paul Bricknell.

Page 1
Tulips on Checked Cloth
21.5 x 28cm (8½ x 11in), inktense blocks on Not
surface paper.

Pages 2–3
The Journey Begins
35.5 x 36.5cm (14 x 14¼in), watercolour paints on Not
surface paper.

Pages 4–5
Who Pays the Ferryman?
35.5 x 36.5cm (14 x 14¼in), watercolour pencils, artbars
and acrylic paints on Not surface paper.

Contents

Introduction

We all have different reasons for wanting to paint and draw. Some will want to enjoy being creative as a hobby to relax and enjoy, while for others it will be a career – perhaps with pressures to succeed. No matter what we choose to paint, or why, it is important to realise that it really only matters to ourselves.

When we are children, we are all artists. We have no inhibitions, we paint with freedom of expression until rules stifle our creativity. It begins with our first colouring-in books when we are told, 'Stay within the lines, don't go over the lines.' The rules of colour even spill over into fashion – remember that phrase, 'blue and green should never be seen, without a colour in between'? What rubbish, I thought! Who says I have to put a colour in between? Needless to say I became a typical art student, dressing in a conflict of colour!

So many people have said to me. 'I was never any good at art at school.' Any dreams they may have had were crushed by the comments of others. Of course we should listen to what others say, but if we can overcome that fear of the finished result and enjoy the process, it will open the door into a world of colour and pleasure which will last a lifetime.

You can paint any subject, you can use any combination of media, you can use any colours, you will receive inspiration from all around you, and – no matter what the results – you should enjoy the creative process, the journey, rather than needing praise for the final result. Of course we all love it when someone says, 'Oh, that's lovely'; after all, it is wonderful to be admired – but if you are painting for admiration rather than enjoyment, then you are painting for the wrong reasons.

I hope that this book will inspire you to unlock your creative potential using an array of sumptuously tempting art materials, many of which you may already have. If not, I hope you may be tempted into getting them when you see what you can achieve with them! Remember that every artist was once a beginner. Indeed, every artist is still a beginner when they step out of their comfort zone and experiment with something new. Everyone develops in some way by stretching themselves, so use this book to help you take a few risks. I hope it leads you in directions you never thought possible on your own journey of discovery.

On the Ferry
23 x 35.5cm (9 x 14in),
watercolour pencils, artbars and
acrylic paint on Not surface paper.

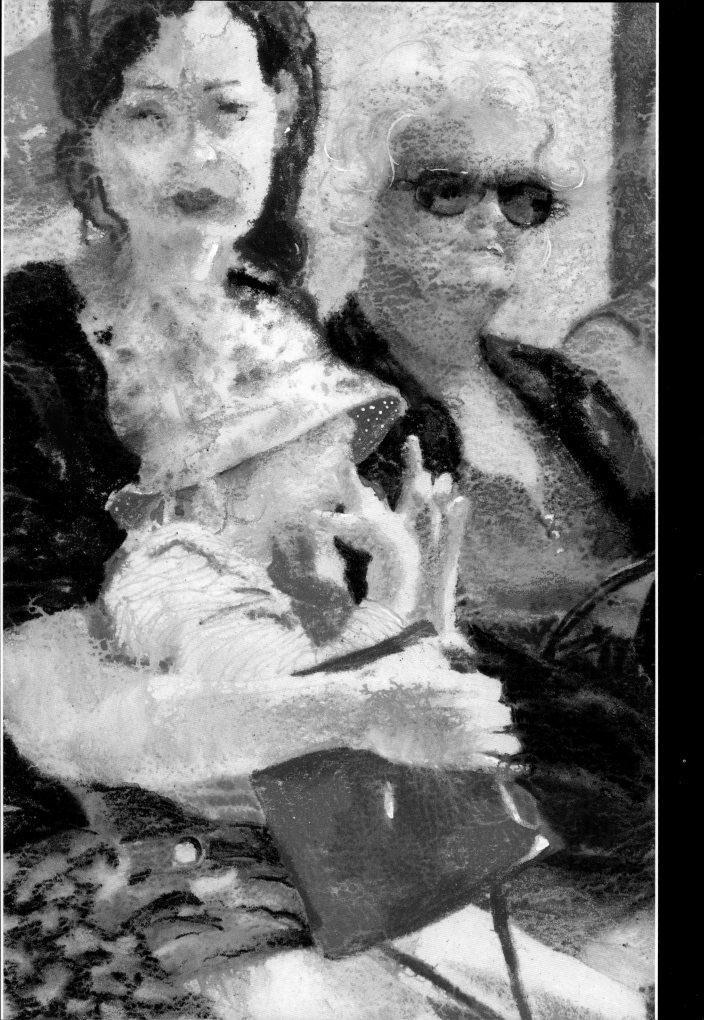

About this book

I am sure that lurking in the back of a cupboard somewhere you have some water soluble pencils, or paints. Once you say you like to paint, the floodgates open to various brightly packaged art goodies and gifts. You can do anything you want to with these materials – the only thing stopping you is the limit of your imagination!

In this book I aim to show you how you can push the boundaries and enjoy using your water soluble art materials in exciting, creative ways. You will be able to adapt all of the ideas in this book in various ways – you do not need to rush out and buy all the different media I use.

This book includes numerous exercises and projects throughout that you can follow, along with paintings and drawings I hope will inspire you. The projects have been written with experimentation in mind, so while I explain the exact materials, tools and techniques that I use in each case, I encourage you to try different water soluble materials and techniques. In so doing, you may invent techniques of your own as well as different ways of achieving things which are not in this book. This is wonderful, and to be encouraged.

Painting is a discovery for us all – whether you create something after reading about it or just discover it for yourself, someone, somewhere will already have 'discovered' something similar. No technique is truly unique, but each painting we complete is unique to us, the artist.

If you get lost or want a little reassurance before you try a particular technique or tool, then you can refer to the *Material matters* chapter on pages 10–17, where I explain the basic properties of each of the water soluble materials used; or the *Vital techniques* chapter on pages 32–47, where I demonstrate a wide range of techniques to try.

This book should be used like a good cook book. Do not expect to do everything in it in order, but allow it to give you ideas to use and adapt in your own painting. Follow the step-by-step projects, but do feel able to change things if you wish, making your project unique. If you are lacking inspiration, sit back with a cup of tea and leaf through this book for ideas to inspire you to get painting again.

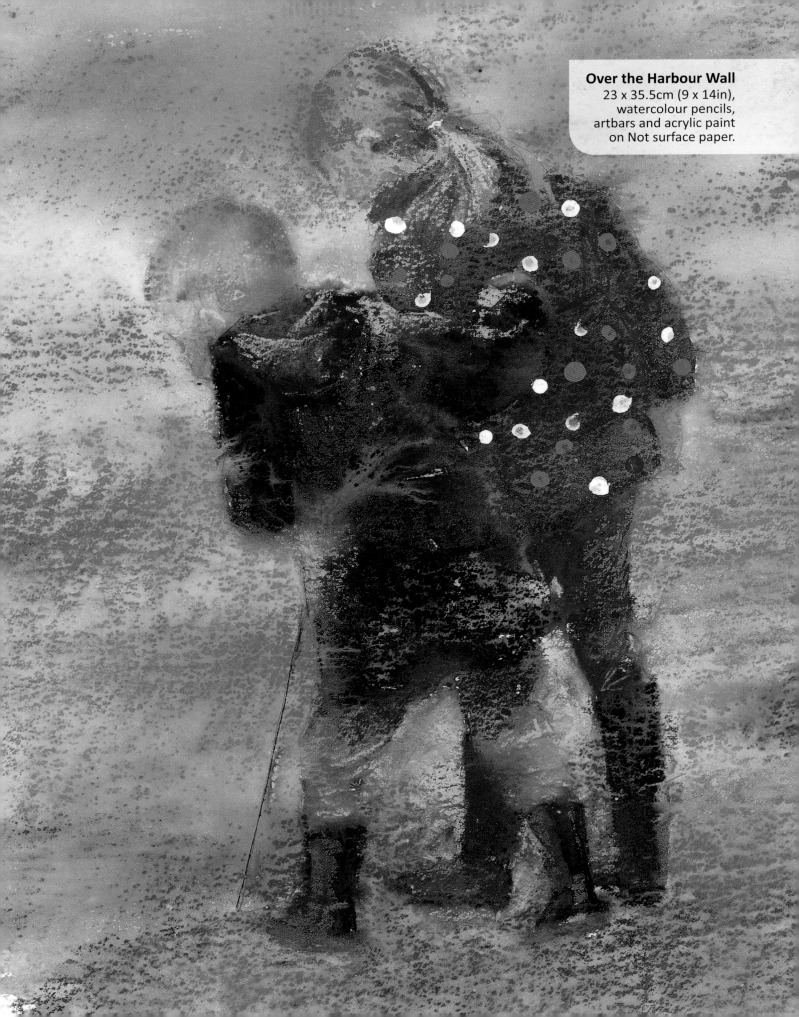

Over the Harbour Wall
23 x 35.5cm (9 x 14in),
watercolour pencils,
artbars and acrylic paint
on Not surface paper.

Material matters

The following pages explore just some of the fantastic water soluble media you can use in your artwork. The quality of the materials you use for your artwork will affect the results you achieve, so I always recommend buying the best you can, even if it means having less.

Colour pencils

Graphitint pencils are made from graphite with just a hint of colour. These feel firm when applied and are most like a graphite pencil to use. Despite having a base of graphite the pigment used is transparent.

Watercolour pencils can be opaque and have subtle hues, in contrast with inktense, which are stronger in colour and both more vibrant and more transparent.

Inktense pencils are designed to be wetted and are different from ordinary colouring pencils. The pigment used becomes lightfast once water has been added, making these truly materials for artists.

Both watercolour and inktense pencils are pigment based, which means the colour you see at the tip of the pencil is the colour you put on to the paper. They have a relatively soft feel on the paper compared with using a graphite or graphitint pencil.

Once you wet inktense pencils, they will dry almost permanent and stain the surface, whereas watercolour and graphitint applications can be agitated and rehydrated. If used on a Not surface paper, a lovely texture can be achieved with the inktense range, while if a smooth surface is used these pencils can be blended and shaded to give very subtle colour mixing. A huge range of tonal values can be achieved by varying the pressure.

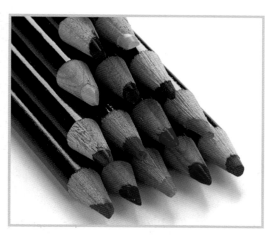

Colour pencils
From top to bottom: graphitint pencils, watercolour pencils and inktense pencils.

Colour sticks

Sticks and artbars come as blocks of solid pigment. They can be round in shape, like a pencil, or angled, square or triangular. The finished result is very different from that achieved using any of the pencils; the texture of the paper is more evident and the thickness of the pigment can not be mistaken for pencil work.

Aquatone paint sticks have a waxy feel and are vivid colours some of which are transparent. They can be applied rather like soft pastels by blocking in lovely areas of opaque colours, or used on their sides to create lines and marks.

Inktense blocks are made from the same material as the core of inktense pencils; simply without the outer wooden casing. Like the pencils, they have a slightly crumbly texture when applied directly to the paper, but once wetted the colour is vivid and translucent, which allows rich deep colours to be created. They are permanent once dry, which enables you to apply layers on top of another without disturbing previous colours. Colour can be lifted directly from inktense blocks with a wet brush (see the picture on the top right of page 48 for an example) and used on many surfaces, including canvas and other fabrics.

Artbars are sumptuously soft sticks of rich opaque colour. When used on their sides and applied directly on to the paper, artbars create bold swathes of colour. Alternatively, the edges of the bars can be used to apply finer, more detailed sections of colour. Being opaque and very soft ensures that they can be used on top of other water soluble colour, which means light colours can be placed on top of darks as well as vice versa. Being opaque, artbars can be used to adjust areas and add bold rich pigment where required. As with inktense blocks, pigment can also be picked up directly from artbars using a wet brush, which allows you to apply the colour delicately for fine adjustments.

Watercolour sticks have similar qualities to paint pans and are ideal for their portability and brilliance. Created using just pure pigment and gum arabic, they can be applied directly on to dry or wet watercolour paper like a pencil. They can also be used like a pan of watercolour paint by lifting colour directly from the stick using a wet brush. They have all the properties of artists' watercolour but in a block.

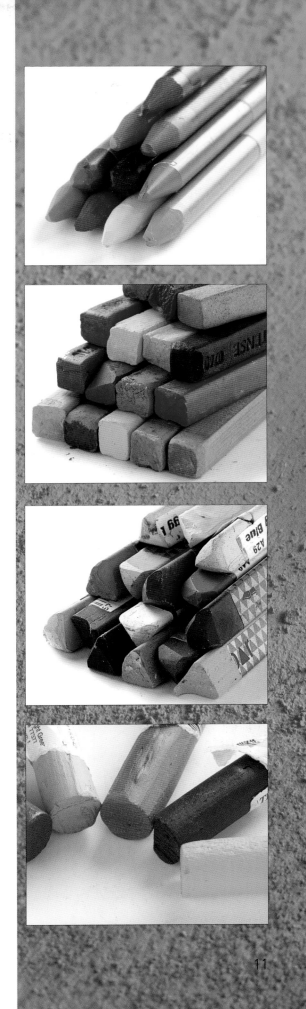

Colour sticks
From top to bottom: aquatone sticks, inktense blocks, artbars and watercolour sticks.

Paints and inks

Watercolour paint is available in either pans or tubes. When water is added to the paint, it can be used as thin transparent colour or strong deep colours. Watercolour can be added to any water soluble pencil work at the start, during or at the end of the painting process. The main advantage of using watercolour paint is having ample transparent colour to drop in or use as a starting point. Once dry, watercolour can be rehydrated and lifted with a brush. Watercolour can be built up in layers by placing wet paint on top of dry, but be aware that layering darker colours on top of lighter ones tends to work better than light on dark.

There is a huge range of watercolour with various qualities that affects the intensity, transparency and luminosity of the paint. The pigment of granulating paints will settle into the texture of the paper and create a lovely textural effect. Iridescent colours reflect light directly, like a mirror, resulting in intense colour and sheen, while interference colours refract light and scatter it.

This means they take on different hues depending on where the light is striking and the viewer's position. Pearlescent colours add an opalescent sheen whilst duochromes bounce between two different colours depending on the reflective light.

Gouache is an opaque water soluble paint which is available in tubes. There are designers' and artists' ranges of gouache. Designers' gouache was traditionally used to create artwork intended for printing, so the pigments did not need to stand the test of time. As a result, these paints are not lightfast. Artists' gouache is lightfast and a wonderful medium to use.

Gouache can be used in thin washes, rather like watercolour, or more thickly, similar to acrylics. When used thickly it is opaque, covers well and can be used as a solid base colour to work upon.

Unlike transparent media such as watercolour, light gouache colours can successfully be placed on top of dark ones due to the opacity of the paint.

Acrylic paints come in various consistencies. Soft flowing acrylics come out of the tube rather like softly whipped cream, while standard acrylics tend to be more like clotted cream, and full or heavy-bodied acrylics tend to be gel-like and stiff. I prefer heavy-bodied acrylics when I use a palette knife, but soft flowing acrylics for use with a brush, which I tend to use the most. Like watercolour paints, there is a huge range of different paints with different qualities that allow for iridescent, metallic and textural effects.

Inks are wonderful and known for their luminous quality and flowing properties. There is such a variety available on the market which vary from being transparent to opaque and even iridescent, allowing many effects to be achieved. Many dry permanently, so they will not lift if the paper is re-wetted. This allows multiple layers to be built up within a painting. All water soluble pencils and sticks can be used with inks.

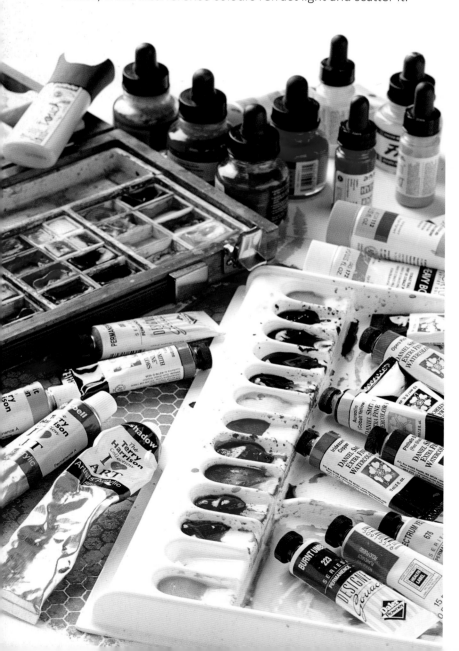

Surfaces

Watercolour paper is available in different weights suitable for a variety of painting applications. A heavier paper is needed when using a very wet approach in which you flood the surface with liquid, while a lighter paper may be used for light washes. The surface of watercolour paper also varies. You can use either smooth or textured depending on the results required.

Watercolour paper is available in a number of finishes. Smooth paper is flattened with a hot press to give a silky smooth surface, ideal for fine detailed work. It is sometimes known as hot pressed (or HP) paper as a result. In contrast, Not surface paper is flattened with a cold press that leaves a slight texture to the paper. This creates the opportunity for textural effects and enhances the use of any granulating pigments. Rough surface paper is also cold pressed and is rougher still than a Not surface. These qualities make it ideal for creating more dramatic textural work and further enhancing the effect of granulating paints and media.

Choosing the correct paper surface is very important to enhance the finished results you require. All of the media in this book can be used on watercolour paper.

Canvas is traditionally made using either cotton or linen, is available attached to boards in various shapes and sizes – ideal for portability – and also available stretched over wooden frames in different depths and sizes. It is suitable for inktense blocks, artbars and acrylic paints, but some media may need fixing with a varnish medium when finished.

Fabrics like silk and other natural fabrics can be used successfully as a surface when using inktense pencils or blocks. Because these media stain, the colour will remain even after washing.

Plaster boards are rigid boards coated in a smooth fine layer of plaster. They are ideal for use with all the media in this book, but the work will need to be fixed with a varnish medium when you have finished.

Tools to apply colour

Paintbrushes Having a variety of shaped brushes allows you to create different effects and will facilitate a wealth of techniques. I use my own range of brushes, but you can use ones with similar properties. The Pointer has a fine tip and holds a lot of water, allowing for fine control without having to reload it often. Any brush with a fine point will work as a substitute. The Classic brush is a versatile large round brush that can be used for applying washes and general work. The Golden Leaf is a larger natural-haired brush suitable for washing and stippling, which allows for great textural effects. The Stippling brush has similar hair but is smaller and round. A 12mm (½in) flat brush is useful for washes and creating sharper lines and corners.

Sponge Both natural and synthetic sponges are useful for applying paint in semi-random shapes. Experiment to create different results.

Lino block These are used for stamping. Similar surfaces can be created by cutting into foam board or polystyrene. Remember that the parts of the image that print on the paper or support will be the raised parts of the lino block (or other stamp), not the parts you cut away.

Pouncers These are strips of rubber, plastic or leatherette, usually with geometric surfaces. They are ideal for stippling to create various textures because the cut edges form a more angled texture compared with that of a brush.

Roller Available in DIY stores in various sizes, these are made from either natural or synthetic fibres. They are used to roll pigment on to any surface to create bold blocks of textured colour. The texture is affected by the thickness of the paint and the type of roller.

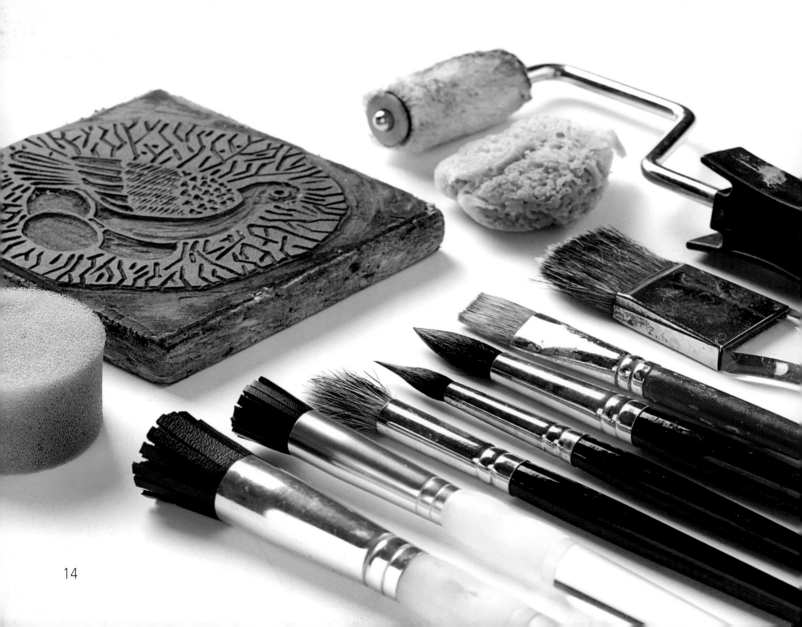

Materials to protect the surface

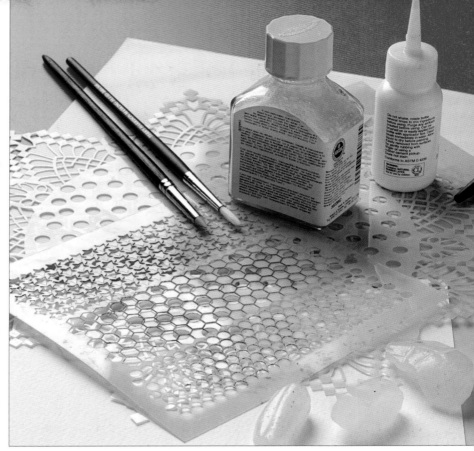

Wax Candles are useful to apply water-resistant wax to areas for a resist effect. Paraffin wax candles work best as beeswax is water soluble. Choose a clear candle rather than coloured ones.

Masking fluid This is a thin latex gum that can be applied to the paper and will protect it from paint until you remove it. I use a bottle that comes with five adjustable nozzles. I cut the nozzle to the size I want; and as soon as I have finished pouring or drawing the masking I rinse it out with clean water. If any stubborn bits remain I use a paper clip to clean the nozzle ready for the next time. Take care when using masking fluid if you intend to draw with pencils or blocks over it as these can scuff the masking and alter the shape and neatness of the masked area.

Permanent masking fluid As the name suggests, this is not removed when the painting is complete. It is a thin pale cream colour and seals into the fibres of the paper. It is not suitable to use on prepared canvas surfaces but can be used on fine silk or cotton.

Colour shaper or old brush Either of these can be used to apply masking fluid to the surface.

Stencils can be made yourself from cardboard or firm plastic, and there are a huge ready-made variety available on the market.

Tracing paper is used not only for tracing images but also for protecting paper. It is available in pads and rolls.

Scrap paper can be used for masks, cut into shapes, or torn to create a rough edge. Lightweight paper is suitable for protecting the surface when leaning on the paper, but a more heavyweight paper is needed if you are using liquids like watercolour paint.

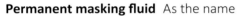

Materials for different effects

Plastic food wrap is useful for creating interesting angled effects.

Granulation medium can be added to wet colour to encourage pigment separation and give a granulating effect to paints that would not usually have the characteristic.

Salt will absorb wet pigment, leaving starburst effects as the paint dries.

A **comb** can be dragged across wet paint, allowing you to make accurate geometric curves and other interesting effects.

Drinking straws can be used to move wet paint in a semi-controlled way by blowing through them.

Soap – including washing-up liquid or shampoo – can be used with wet paint to create bubbles that will leave circular marks when dry.

Bubble wrap can be painted upon and then used to print circular shapes and patterns on your surface.

Polystyrene, often used for packaging, can be used for printing and moving paint.

Crumpled paper is a cheap, disposable way of creating random angled shapes with printing.

Corks are useful for printing and stamping.

Sticks or **dip pens** can be used for drawing and teasing out wet paint.

Empty rolls of masking tape are useful for printing rings or curves.

Cotton buds/swabs are useful for applying or lifting colour.

Thick card can be used for printing straight lines or you can cut out shapes to be used as masks.

An **old flat brush** and **burnishing tool** are used together to flick paint or masking fluid on to paper. The burnishing tool is drawn backwards across the loaded brush's wet bristles, which flicks them forward to create speckles. The burnishing tool is also used for bruising marks into paper or teasing out paint.

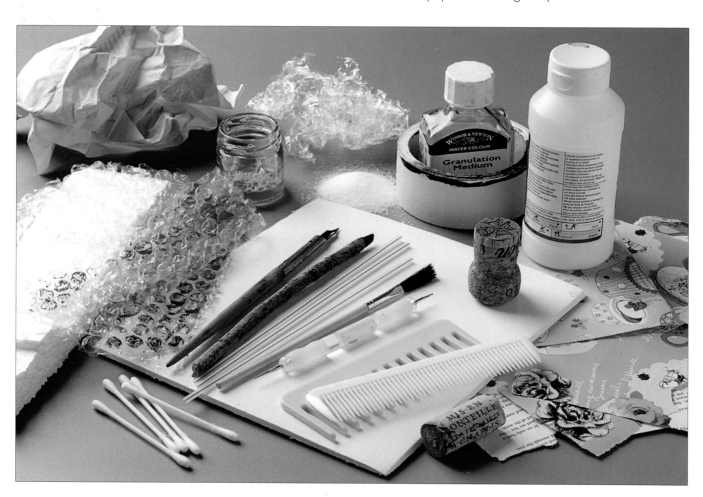

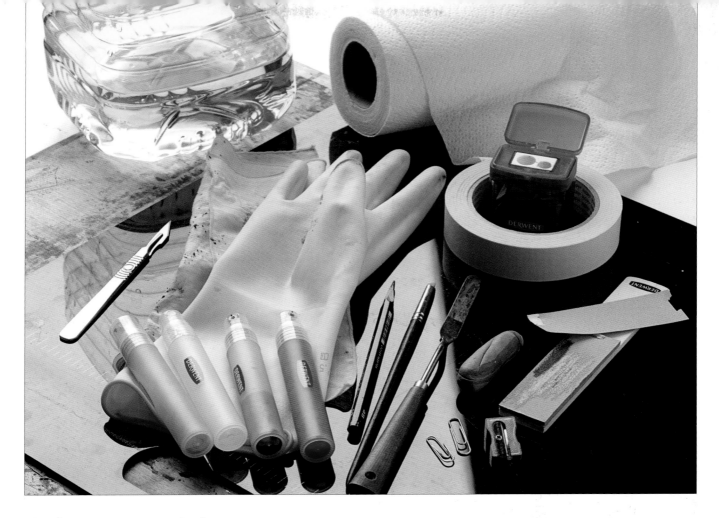

Other materials

Sandpaper block Dry pigments from colour sticks and pencils can be rubbed on to the block, breaking it into tiny speckles which settle into a wet surface. This creates fantastic effects.

Drawing board Used to lean on and rest your work upon, a drawing board allows you to work at various angles. Securing your paper (or other surface) to a board also makes it easy to handle for tilting wet colours to enable them to run.

Masking tape This is used to attach paper to the drawing board, and also to protect straight areas or blocks of the paper surface on which we want to avoid certain colours.

Putty eraser A simple tool which can be used to remove pencil lines or lift pencil tone.

Water pot Used to hold clean painting water; I recommend a fairly large one.

Scalpel or **craft knife** These can be used to sharpen pencils or sticks, and also to scrape tiny dry pigment particles on to a wet surface or cut paper.

Pencil sharpener This is equally useful for sharpening coloured pencils and colour sticks.

Spray bottles Filled with clean water or dilute pigments made from watercolour paint or inks, these can be used to spray a soft mist of water or colour on to the surface.

Soft cloth This is used to protect your fingers and the paper surface when removing masking fluid.

Paper clips These can be used to clear the nozzle of your masking fluid if it becomes clogged.

Rubber gloves Used to protect your skin from colour, these are especially useful when using inktense blocks with a sponge.

Palette knife A small palette knife can be used to apply, move and flick pigment.

Graphite pencil When creating or transferring a line drawing, an HB graphite pencil is the obvious tool.

Colour shaper This rubber-tipped tool is used to apply or move pigment, and to apply masking fluid.

Creative discovery

You buy the materials, they look appealing, you read the directions, you excitedly use them – but the results do not necessarily match your expectations. This part of the book will help you to bring out the best of your materials in order to allow you to make a splash with water soluble media.

What is in your forgotten treasure chest? We can have all sorts of painting materials in cupboards, untouched. Get them all out and have a good sort through them. Whatever they are – inks, paints, pencils – you will be able to produce a striking painting with them.

Using what you have

The exercises on the following pages will allow you to explore the materials that you have, and help to show you some of the combinations you can use. Later in the book, I will show you how to use the water soluble materials covered on pages 10–17 with specific techniques (see pages 32–47), but these first exercises are intended to help you to simply enjoy using what you have before you look further into drawing and painting.

Do not be afraid of wasting paper. I know so many people who worry that the paper costs so much, and think that it is a waste not to paint a proper picture on it. You need to acknowledge that in order to develop and succeed, you will need to experiment and use lots of paper. I am using large Imperial sheets of Bockingford 300gsm (140lb) paper with a Not surface for these exercises. I usually cut such large sheets down to more manageable sizes: 76 x 56cm (30 x 22in), and 38 x 28cm (15 x 11in) for smaller work, but you can use any textured watercolour paper you enjoy using. Make sure it has a tooth to it though; it should not be smooth or the lovely textures that we are about to achieve will be lost.

No matter what you actually end up with in your experimental works, always keep them, you will be able to work over them with layers later and develop these works as you develop your skills. Some people throw their trial work away. I encourage you not to: these works are part of your journey of discovery, there may come a time in the near future when you need a base to experiment on with lovely thick pigment.

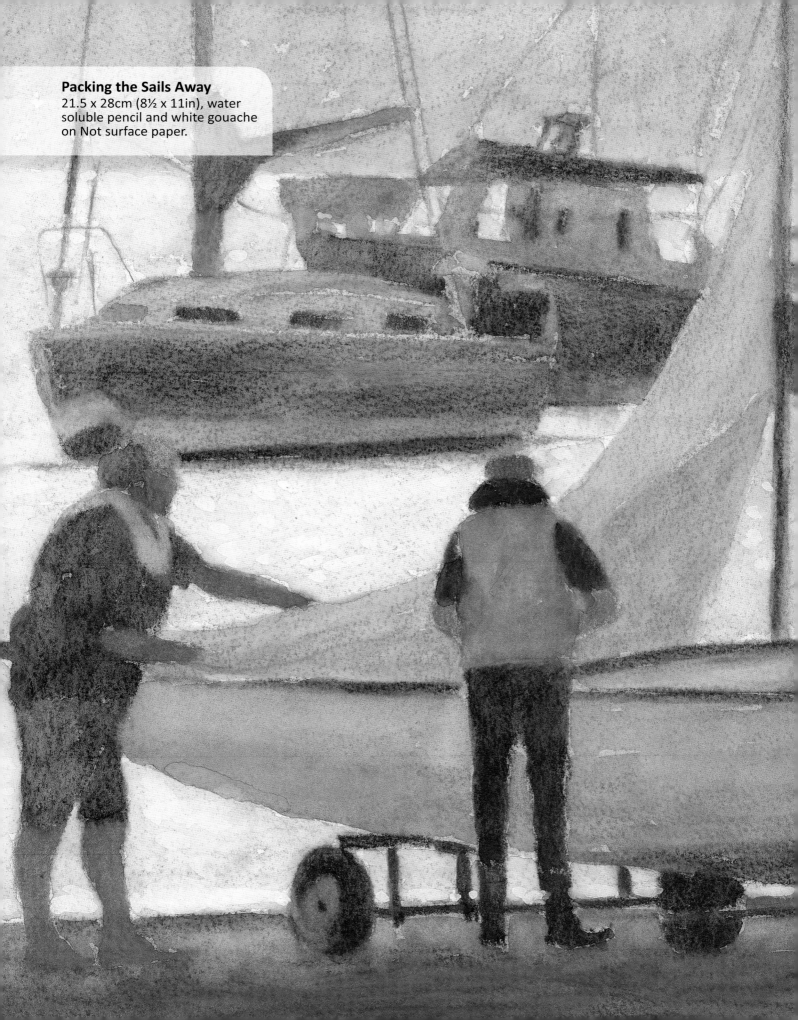

Packing the Sails Away
21.5 x 28cm (8½ x 11in), water soluble pencil and white gouache on Not surface paper.

Just add water

Get out all of your water soluble materials – it does not matter if they are pencils, sticks or paint – then think of the colours that you like. They can be any combination: this is your creative time, so use colours you particularly like.

The main reason for experimenting in this way is to gain an understanding of how various media work together: some flow more than others, some are opaque and cover any colour placed underneath, and some react with others to create various effects. Watch what happens on the wet paper and you will soon find colour and medium combinations that you enjoy using most and these will feature more in your work in the future.

This exercise will involve using one layer of your water soluble medium to suggest a simple landscape. While I have provided a list of the materials I used (see right), the purpose of these exercises is for you to work with what you already have, so you should simply use the materials listed as very rough guidelines.

If something does not work as you had hoped, think about what happened and how you could use that idea for something else; do not think of it as a failure, but as another discovery to use in the future. Most importantly, enjoy the whole process. Get your water soluble materials to hand, and you are ready to begin!

MATERIALS USED:

Watercolour pencils: raw umber (56), cobalt blue (31), light violet (26)

Inktense pencils: cadmium yellow (0210), cadmium orange (0250), iron green (1310)

Artbars: iris (A10), kiwi (A18), blush (A23), opaque white (A72), lilac (A27)

Inktense blocks: cadmium orange (0250), iron green (1310), poppy red (0400)

Not surface watercolour paper, 300gsm (140lb), 33 x 23cm (13 x 9in)

Large round paintbrush

Masking tape and board

Spray bottle

1 Secure your paper to the top of the board using masking tape, then suggest the basic shapes of a landscape on the paper using whatever water soluble medium you have chosen. I am using a raw umber watercolour pencil for this example. Alternatively, you can skip this stage and go straight in with colour by starting at step 2.

2 Loosely block in the shapes using any of the different media you have. I have used cobalt blue and light violet watercolour pencils on the sky and distant hills, cadmium yellow and cadmium orange inktense pencils along with contrasting iris, kiwi and blush artbars on the mid- and foreground fields, and white artbars on the buildings on the horizon.

3 Use a spray bottle to spray the picture. Let the water mingle and cover the colour naturally.

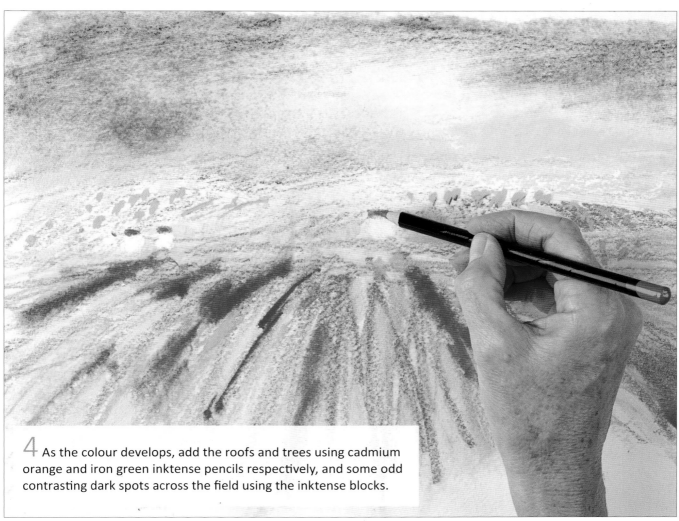

4 As the colour develops, add the roofs and trees using cadmium orange and iron green inktense pencils respectively, and some odd contrasting dark spots across the field using the inktense blocks.

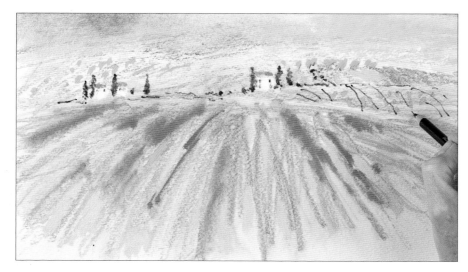

5 Strengthen the wet colours by picking up colour from the poppy red inktense block with a wet large round brush and touching it lightly to the surface; and suggest detail in the background with iron green and cadmium orange inktense pencils.

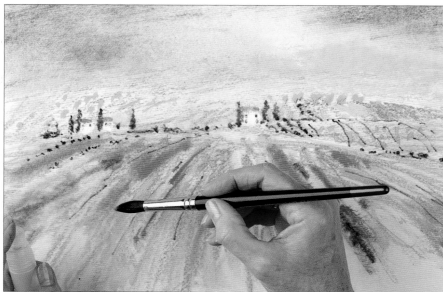

6 Continue developing the picture by playing with the media you have. Experiment with what each does while the paper is wet, and when it is merely damp. If the wet sheen disappears from the paper, you can re-spritz it, or just individual areas.

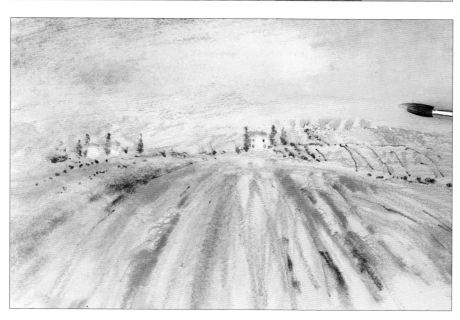

7 Continue to play and develop the picture. Here I am softening the texture on the top right with a wet brush loaded with opaque lilac artbar.

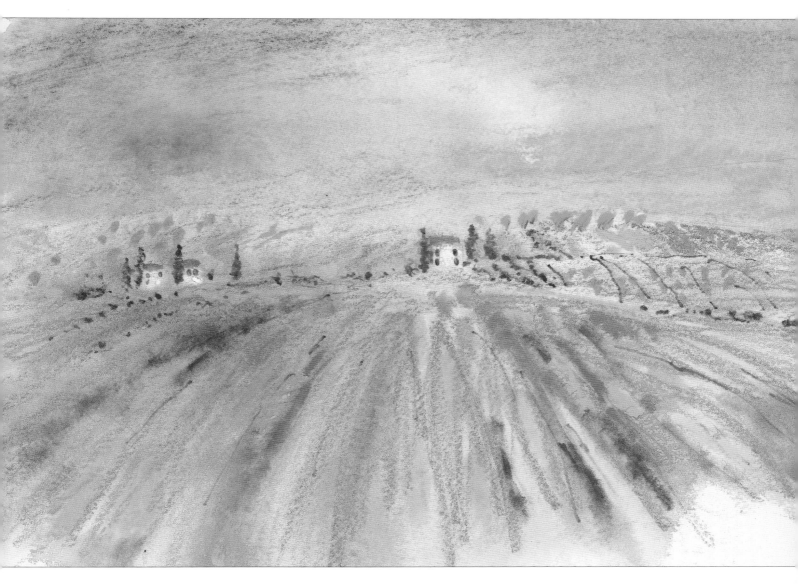

Tuscany Fields
You have now created the most wonderful textural study. It might be so good that you want to keep it as it stands. It may also be ideal to work on further at a later date.

Making a splash

This exercise will let us begin to move the paint and leave dry gaps, create splash sections and tilt the paper. After all, we do not have to keep the board flat – tilting it allows us to move the wet paint where we want it to go. As before, secure a large sheet of lightly textured watercolour paper to your board using masking tape before you begin.

We will also drizzle water through the paint to create the lovely textures, granulations and runs that are such an important part of using water soluble media in your painting.

As before, the materials list to the right is simply what I used, and you should practise using whatever materials and colours you already have.

MATERIALS USED:

Watercolour pencils: sky blue (34), ultramarine (29)

Watercolour paints: permanent rose, cobalt violet, Winsor lemon, cobalt blue

Not surface watercolour paper, 300gsm (140lb), 33 x 23cm (13 x 9in)

Large round paintbrush

Dip pen

Sandpaper block

Masking tape and board

1 Secure your paper to the board using masking tape, then lightly suggest some basic shapes to follow using a light watercolour pencil – like sky blue, as I use here. Alternatively, you can start at step 2 by painting directly on to the paper.

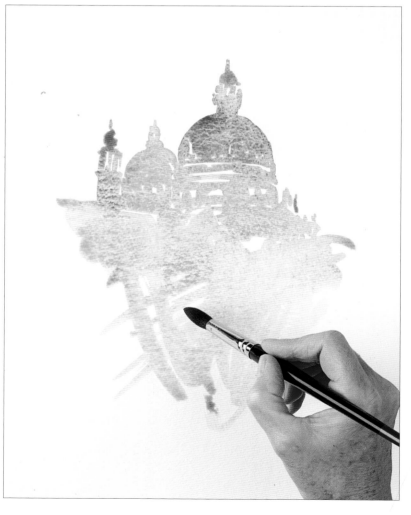

2 Use a large round brush and dilute watercolour paint – I am using permanent rose and cobalt violet – to block in the shapes, leaving spaces of clean, dry paper.

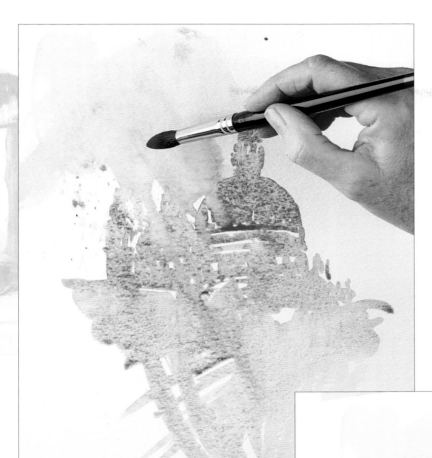

3 While the paint is wet, add an area of very dilute light-toned watercolour paint, such as Winsor lemon, at the top and tilt the board so that it begins to run down. Spatter on some other dilute colours such as cobalt blue into the top area by sharply jerking the brush over the area.

4 Keeping the board tilted, pick up some clean water with a dip pen, and spatter it on in the same way. You can use a brush if you prefer.

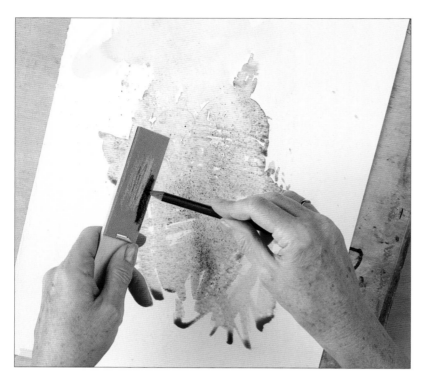

5 Keeping the board tilted – with a block or book, if you need both hands – experiment with adding other water soluble media. Here I am rubbing sky blue and ultramarine watercolour pencils over a sandpaper block, letting the filings fall into the wet paint.

6 Continue to develop the picture and explore your media by playing with the various techniques such as spattering the surface with dilute paint. Keep the board at the same angle until it has dried completely.

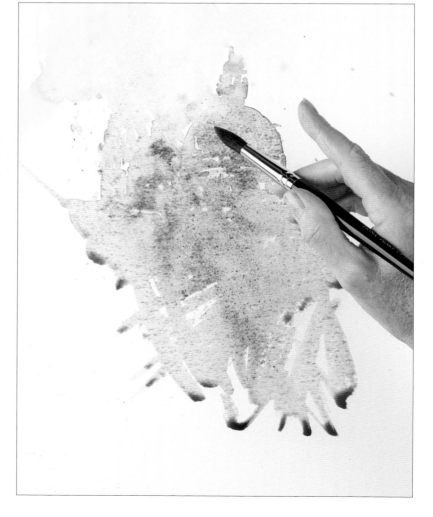

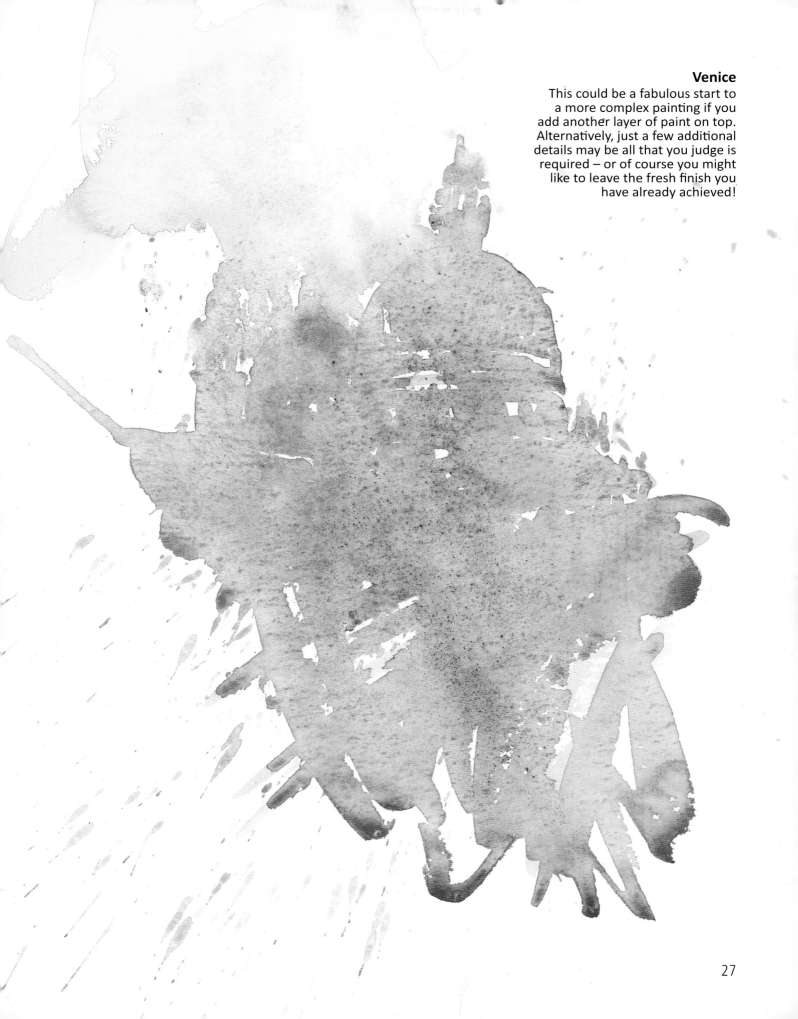

Venice
This could be a fabulous start to a more complex painting if you add another layer of paint on top. Alternatively, just a few additional details may be all that you judge is required – or of course you might like to leave the fresh finish you have already achieved!

The creative journey

Now that you have experimented with the materials you already have, continue to create and experiment. Discovering what our pigments do is crucial to creating meaningful work. If everything we achieve is merely a happy accident, then our results are all based on chance and luck, so understanding how to create different effects is vital and a joy to discover.

Getting organised

Get a large sheet of card (I use the card that my sheets of paper are actually delivered in) fold it in half and use it as a folder to store all the different stages of your work. I stand my folders in a browser, each folder clamped with an old-fashioned bulldog clip. This allows me to quickly find previous works either for reference or to work on.

I work in quite an organised way, but if you are the sort of person that enjoys piling things up, then do whatever works best for you. Just remember – do not throw anything out!

My card folders, packed with finished paintings, works in progress and rough exercises.

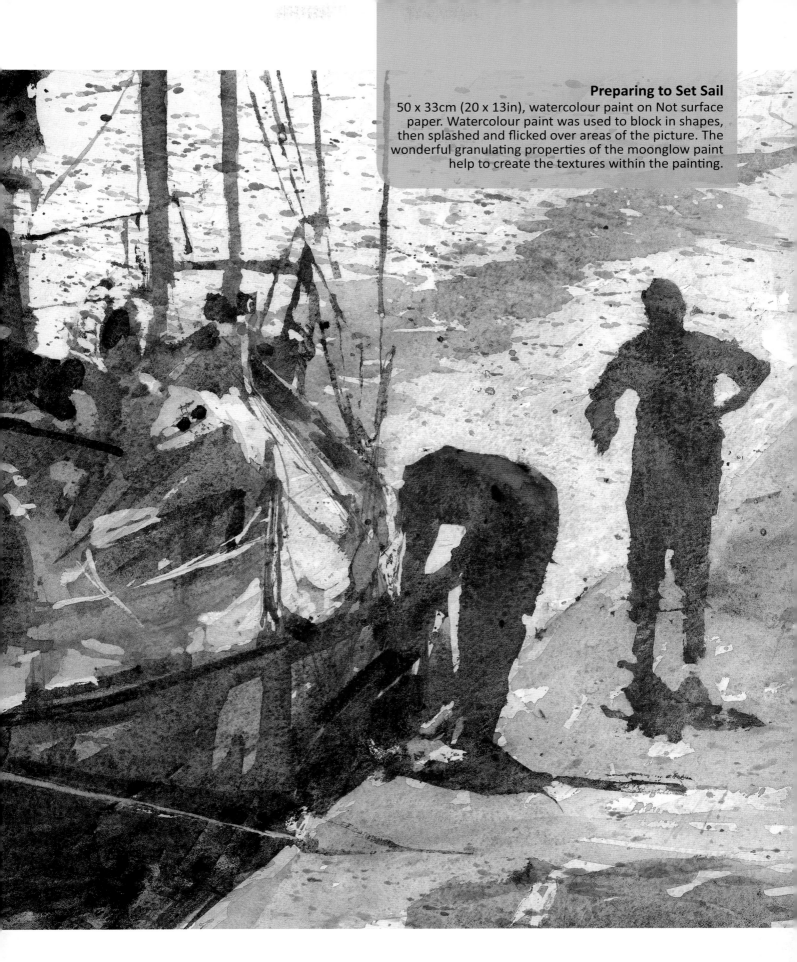

Preparing to Set Sail
50 x 33cm (20 x 13in), watercolour paint on Not surface paper. Watercolour paint was used to block in shapes, then splashed and flicked over areas of the picture. The wonderful granulating properties of the moonglow paint help to create the textures within the painting.

Lavender Fields at Snowshill
33 x 18cm (13 x 7in), artbars and inktense blocks on Rough surface paper.
For this panoramic painting, bold pigment was drawn on to the paper, then
sprayed with clean water and left to settle into the surface.

Vital techniques

Although in principle the four basic techniques detailed over the following pages can be used separately, when used together, they form endless creative possibilities – just like the eight notes on a musical octave.

Dry on dry

For dry on dry techniques, both the water soluble medium and the paper or support are dry. Water can be added later, but the critical point is that both medium and surface are dry initially. This technique is only applicable to dry drawing media such as pencils, sticks and artbars.

The paper surface has an incredible effect on the final results, so choosing the most suitable paper for each project – whether using pencils or colour sticks – will save time and frustration in the future.

If you are using a smooth surface, such as hot pressed paper, you need to create any texture and marks by scribbling with the tip of the pencil. A Rough or Not surface paper automatically gives a textured result, so bold areas of texture can instantly be achieved using the side of the pencil. Texture can be removed when wetting but this can also result in churning up the colours.

Pencils on a smooth surface
This surface is wonderful for detailed work such as botanical or photorealistic projects.

Using pencils

The way we hold the pencil, and the pressure we apply, changes the results we achieve. More pressure gives a stronger colour, less pressure a lighter colour. Holding the pencil near the sharpened end results in more control than holding it further back. I usually recommend holding the pencil about 1cm (½in) from the tip.

The point of any type of water soluble pencil or stick can be used for creating delicate details, patterns and lines as well as fine shading and blending of colours.

The side of the stick or pencil tip can be used for blocking in and covering a larger area quickly. In order to use the length of the pigment area, place the pencil in front of you, place all of your fingers in a row on top of it, with your forefinger about 1cm (½in) from the point. Roll your thumb under the pencil while picking it up. Adjust your fingers for comfort and use the flattened pencil to block large sections of colour on to the paper.

Pencils on a textured surface
This paper is ideal for very textural subjects or more lively art projects.

Blending colours

Pencils can be blended together dry on dry to give subtle colour mixes. The colour on top will always be more obvious than the one underneath. Colours can easily be erased using either a plastic eraser or a battery operated eraser. However, once wetted, this is not so easy, so erase highlights or adjust before wetting.

Wetting dry on dry work

Wetting pencil work that has been made dry on dry enhances the colours as well as making many colours lightfast. This medium is intended to be wet, and there are various ways to do this. Gently misting the surface with a spray bottle is ideal for retaining the intricacy of fine detailed work, or to create pools of liquid which you can then tilt.

A soft natural-haired brush will gently move the pigment without churning up the colours, allowing you to keep the effects you want and retaining any lines and marks. Apply more pressure or use a synthetic brush to remove such marks or to blend colours more thoroughly.

Flower Study
18 x 19cm (7 x 7½in), watercolour pencils on Not surface paper. Textures were created dry on dry by scribbling and allowing colours to overlap and merge. The lines on the leaves were applied using bold strokes while the flower centres were applied more delicately. A large round brush was then used to wet the paper, avoiding tiny sections and trapping sparkles of light.

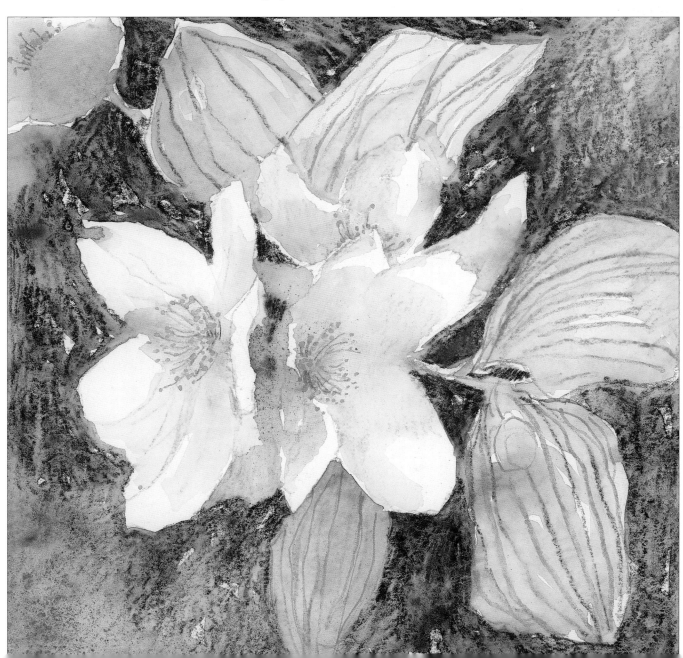

Using colour sticks

Sticks and artbars can be applied by placing the block flat against the paper and pushing it across the surface. Ideally I recommend snapping the blocks into two unequal pieces, one-third and two-thirds of the stick, as this allows more control when choosing the size of the block to use to apply the pigment.

The type of stick will also feel different, inktense blocks feel firm and hard, aquatone sticks are softer and artbars are softer still, sometimes verging on sticky. The softer the block, the more pigment sticks to the paper. In all cases, the harder the pressure you use, the more pigment is applied.

The edges of the block can also be used dry on dry to create lines, marks and dots. The effect with sticks will be bolder than when using pencils. Blending and mixing colours is done in the same way as with pencils but the results are bolder.

Wetting colour sticks

Wetting colour that has been applied with sticks enhances the colours as well as making many colours lightfast.

You can gently spray clean water over the area with a spray bottle, allowing the pigment to move freely and create pools of liquid which you can then tilt. If you are using artbars, spraying and tilting reveals little islands of colour which can create wonderful effects. This technique can only be achieved with very soft blocks which need to be applied quite firmly. Soft focus edges can also be achieved using this method.

As with watercolour pencils, any brush used to wet the colour needs to be very soft to avoid disturbing the texture. For this reason, I recommend natural-haired brushes when wetting colour sticks.

Colour sticks on a smooth surface
Using smooth HP paper, dry inktense blocks can be used on their sides and blended, and the edges used to create bold lines and spots on a dry surface. Water can then be added using a spray bottle, a soft brush, or both to make the colours permanent.

Colour sticks on a Not surface
Dry artbars used on their edge and pushed across dry Not surface paper creates a rough texture. Water can subsequently be sprayed on to parts of the area and the colours allowed to blend, which results in islands of colour forming naturally. Once dry, more colour can be added on top.

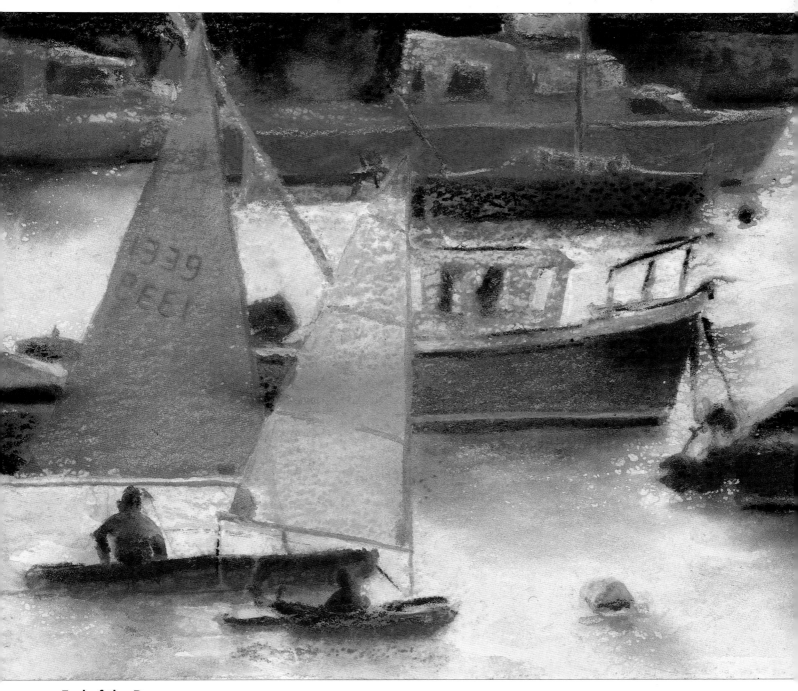

End of the Day
26 x 22.5cm (10 x 8¾in), inktense pencils and artbars on cotton rag Not surface paper. Inktense pencils were used to block in the colours then white artbar was applied to lighten areas. The whole painting was sprayed using clean water from a spray bottle and the board was then tilted left and right to allow the colours to flow horizontally into one another. Once dry, touches of white and pale cobalt artbars were added.

Dry on wet

For this approach, the medium we use is dry while the paper or support is wet. This is applicable to drawing media such as water soluble pencil, sticks and artbars. As with dry on dry techniques, the paper surface still affects the results.

How wet?

The pigment will react differently on a damp surface than on a soaking wet surface; experiment with different levels of wetness. Applying the water by spraying, using a brush or flicking droplets on to the paper will also give different results.

Any lines or marks drawn directly on to a wet surface using water soluble pencils or sticks will remain, giving a result similar to that of a felt-tip marker pen. These lines can not be removed by rubbing afterwards, so care must be taken to place them in the correct place.

The edges of the blocks can be used to create crisp lines. Alternatively, swathes of dramatic colour can be created by using the sides.

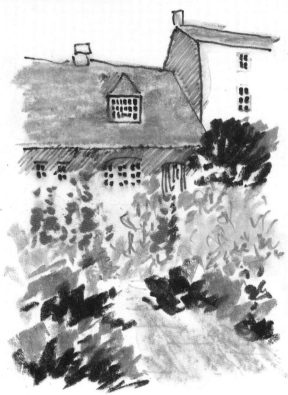

Colour sticks and pencils on Rough paper
Here, a sheet of Rough watercolour paper has been sprayed with a spray bottle and bold swathes of turquoise have immediately been blocked across the paper using the flat side of the artbar. Magenta and mustard hues were added on top using the ends of inktense blocks, then more lines were added using graphitint pencils, all before the paper had dried. Providing the surface is not too wet, such lines and marks will all remain, as will the texture of the paper.

Colour sticks and pencils on smooth paper
Smooth HP paper was wetted all over using a soft brush before watercolour pencil tips were used to create strong lines and smaller shapes on the wet surface. Inktense blocks were used on their sides to make marks, dots and scribbles before artbars were placed flat on the wet paper to place broad blocks of colour. All this was completed whilst the paper was wet. If the paper begins to dry, it can be re-wetted. The lines will not move if placed on to a wet surface.

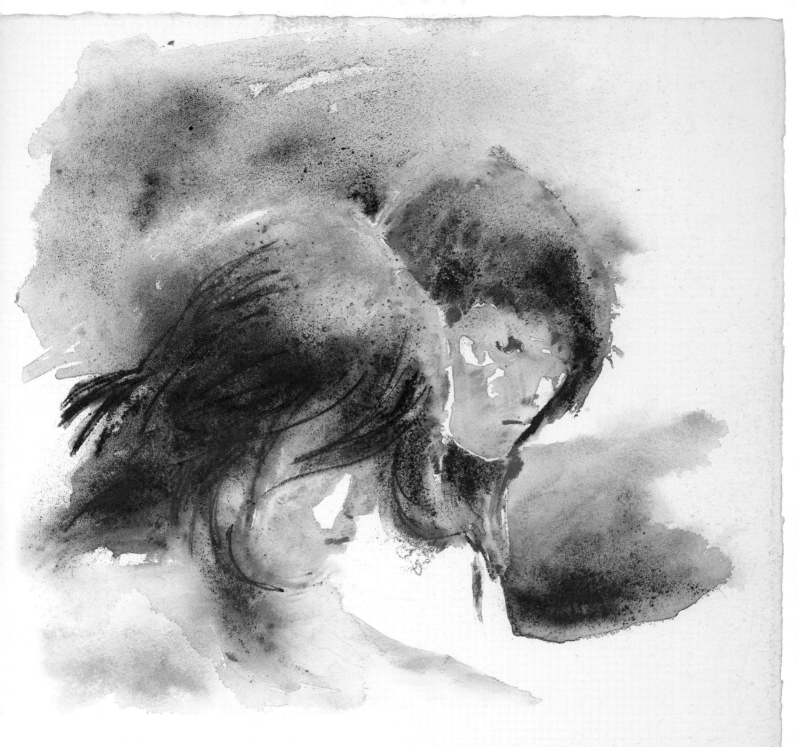

Two's Company

37 x 37cm (14½ x 14½in), inktense blocks, artbars, watercolour pencils and graphitint pencils on Not surface paper. This entire painting was created using dry on wet techniques. A large round brush was used to wet the sections which were to become the figures, then artbars were used to boldly block in the sections of colour. While this remained wet, the background sections were sprayed using a spray bottle, colour was gently rubbed over the wet surface using artbars and the board was then tilted, allowing the colours to flow into one another. The dark lines were immediately drawn on top of the wet colours using inktense blocks. While still wet, watercolour pencils, graphitint pencils and artbars were speckled on to the surface.

Floating colours

Once the paper is wet, we are also able to 'float' colour on the surface by stamping or scraping dry pigment on the wet area.

Stamping

Stamping on damp paper using linocut blocks, paper/card shapes, polystyrene or similar surfaces can result in some wonderful textures. This can be particularly useful if you need repeated shapes – or indeed any shape you can easily make from the stamping material.

Wetting the paper correctly for this technique is important – too dry and the image will not appear clean; too wet and the image will begin to run.

Scraping

Using a craft knife to scrape colour from pencils or blocks on to wet paper allows coils – or if the medium is scraped over sandpaper, tiny speckles – to fall on to the wet paper for an interesting effect.

The longer the stroke, the longer the resulting coil. Colours will remain separate and only dissolve where the paper is wet; any remaining pigment dust left can be blown away once the paper has dried completely.

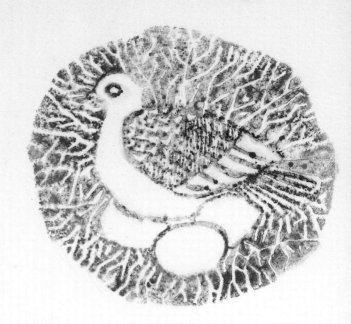

Stamping
Inktense sticks have been rubbed over a lino block, allowing the colours to overlap and merge. The block was then firmly pressed on to wet smooth (HP) paper and lifted away.

Scraping with a craft knife
The small coil shapes on the example above were achieved by scraping a watercolour pencil with a scalpel or craft knife blade, allowing the coils to fall on to paper that had clean water scribbled and flicked over the surface. Artbars can be used in the same way, and they result in blocks of colour which dissolve almost instantly.

Scraping with sandpaper
Here, water has been scribbled and flicked on to the surface. Graphitint pencils were then rubbed on the coarse surface of a sandpaper block, allowing tiny speckles to fall on to the wet paper. Tap the sandpaper block to encourage more colour to fall.

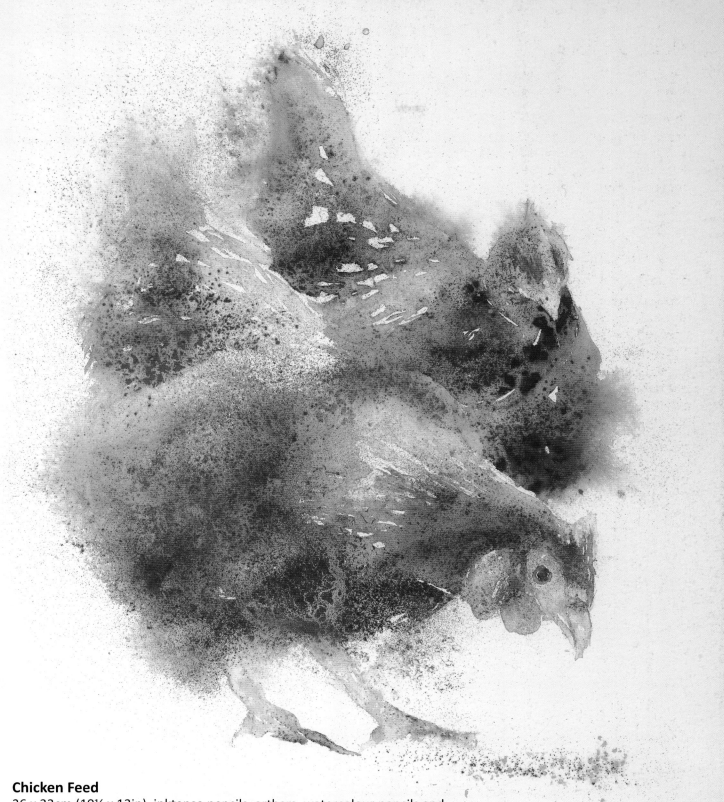

Chicken Feed

26 x 33cm (10¼ x 13in), inktense pencils, artbars, watercolour pencils and graphitint pencils on cotton rag Not surface paper. This entire painting was created on wet paper using the scraping techniques described opposite to apply the pigment. Areas initially left dry remain as sections of trapped light or as colour boundaries where dark colours are adjacent to lighter ones. Soft edges were created by spraying water on to the painting using a spray bottle and artbars were speckled on to the surface to create more intense sections of colour to finish.

Wet on dry

For this technique, the media we use are wet and the paper or support is dry. Media which need water to dilute them include watercolour, gouache, inks, acrylics, water soluble pencils and water soluble sticks.

Using a brush to place paint on to paper is the most common approach to wet on dry work, although there are many other ways to use this technique, some of which are commonly ignored. Tools such as pouncers, stippling brushes and rollers, and household items such as card, kitchen paper, and bubble wrap can be used to add colour to the surface. When using objects to place pigment, remember that paint will only go where you put it and will not run into adjoining sections unless two wet areas touch.

Layer upon layer can be created providing each layer is allowed to dry. Paint can also be sprayed on to the dry paper using speckling tools, diffusers or spray bottles; or flicked on from a brush or other tool. Paper, card or acetate stencils can be used to mask paper to avoid colours overlapping where they are not wanted.

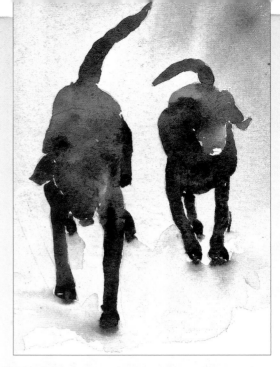

Two Dogs
10 x 14cm (4 x 5½in), watercolour paint on Not surface paper. Areas of colour were painted on to the dry paper using a large round brush, suggesting dogs running towards us. To prevent the features disappearing into one big shape, tiny gaps of dry paper were left to separate body parts or suggest light. The paint will not run into these dry areas.

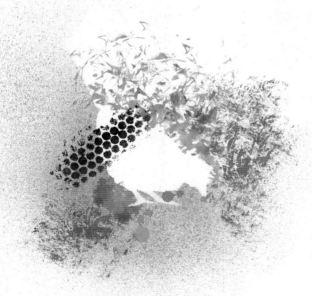

Masks and stencils
A crumpled sheet of scrap paper was dipped in dilute purple inktense then randomly stamped on to the surface over a chicken-shaped paper mask. Pink inktense in a spray bottle was used as a colour spray over the top. Once this had dried, the crumpled paper was dipped into a strong mix made of red and purple artbars and pressed over the previous colours. Finally a stencil with holes in it was placed over the paper and damp kitchen paper pressed against a dark purple artbar, which was then used to press on to the stencil.

Unusual tools
For this example, pink and blue inktense was stippled on to smooth HP paper. Once dry, orange inktense was pressed on using a cotton bud/swab, while deep purple and mauve artbar pigments were painted on to bubble wrap and a wine cork which were then firmly pressed against the paper. Finally, ochre artbar was painted down the edge of a small piece of card and pressed on to the paper. The thicker the paint, the better the result.

Twist and Shout
28 x 40cm (11 x 15¾in), inktense blocks, stamping and multimedia. Once I had established a background, I cut out a simple figure-shaped mask (complex shapes will not be visible with all the surrounding pattern) and secured it temporarily with adhesive putty. This is a wonderful technique to use, and it really helps to find out which media and colours work well on top of each other.

Brushwork

A brush can be used to create a wet shape on the paper and those shapes joined together. These shapes will always have hard edges except where any shape touches, where they will merge. This is a brushstroke – as opposed to blocking in an outlined area with colour.

Tools and household objects such as toothpicks, embossing tools, darning needles, or paintbrush handles can be used to move paint. Providing we first place a blob of wet paint on to the paper, we are then able to move it. It will not move on its own unless the adjoining section is wet.

Combed paint

Once a blob of wet colour is placed on the paper, it can be moved and its shape altered using tools such as a comb, which can be used to drag the paint in lines and swirls along the surface of the paper. Paint can also be splashed and flicked out of the end of the brush, creating tiny round shapes of colour.

Straw-blown paint

A blob of paint can be placed on dry paper, then blown using a drinking straw. This is such a fun technique and, depending on how the straw is moved, some wonderful loose shapes can be created. Note that you need to take a break now and again – you can get a bit light-headed if you get carried away!

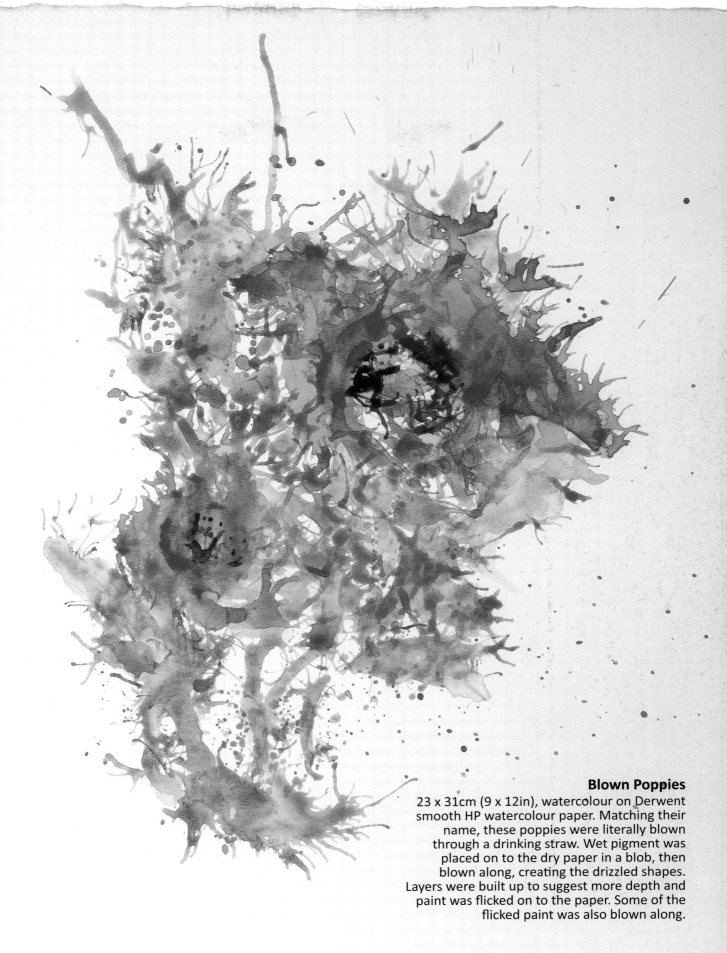

Blown Poppies
23 x 31cm (9 x 12in), watercolour on Derwent smooth HP watercolour paper. Matching their name, these poppies were literally blown through a drinking straw. Wet pigment was placed on to the dry paper in a blob, then blown along, creating the drizzled shapes. Layers were built up to suggest more depth and paint was flicked on to the paper. Some of the flicked paint was also blown along.

Wet on wet

This technique – where both the media we use and the paper or support are wet – is especially effective when using inktense blocks, artbars, watercolour and inks. It is not as effective using pencils, although swatches of colour can be boldly blocked on to paper and lifted using a wet brush.

Wet on wet is a fabulous technique which involves allowing pigments to meet and merge naturally on the surface, then dropping in colours to alter the outcome. Transparent colours tend to work better, but experiment with opaque paints, too. Some pigments separate or granulate, giving special effects, while others rush across the wet surface. Getting to know what the various pigments will do is an exciting challenge.

The varying stages of wetness will also affect the outcome, so the way the paper is wet is important. The surface can be sprayed using a spray bottle, stippled using a stippling brush, flicked or washed using a brush.

Wet on wet techniques allow us to manipulate the pigments to create unique textures and shapes on the paper, most of which can not be repeated exactly, although the effects can be created over and over again.

Once you understand what the pigments you use can do, you will begin to choose your favourite combinations to create certain effects within your work.

Ink spritz
Gently spray the paper using a spray bottle filled with dilute pink ink, then drop swirls of watercolour and inks on to the pink surface. The paper can then be tilted to allow the pigments to react and move.

Pen and ink
Spray the surface with water then draw circles of red and yellow ink on to the wet surface. The ink will disperse into the surface at varying rates depending on the wetness of the paper.

Brushwork with mixed media
Dilute yellow ink was applied to the paper using a large round brush, then watercolour and artbar colours were introduced and allowed to merge. Some colours react and separate, creating lovely textures.

Sprayed ink and colour blocks

Dilute pink ink was sprayed on to the paper, then strong red inktense was swirled in circles through the pink. Yellow was flicked on top of this and allowed to merge, then opaque white artbar was swirled on top. Bright green inktense was then scribbled below the pink to suggest leaves and a granulating watercolour was then dropped on to the surface and allowed to separate and move through the wet area. Opaque turquoise artbar was then added to the green.

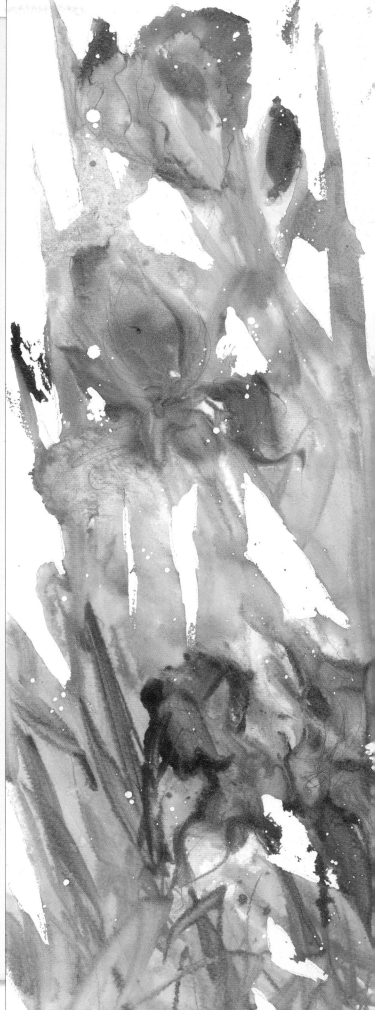

Blue Iris in the Garden

18.5 x 53.5cm (7¼ x 21in), acrylic inks and iridescent inks on Not surface paper. Masking fluid was applied randomly to the paper in blocks and spots. Once dry, the paper was wet all over with clean water. Iridescent inks were then drawn, dropped and flicked on to the wet paper, allowing the suggestion of irises to appear. Finally, the masking fluid was removed to leave areas of dry protected paper.

Ink and watercolour paint

For this example, the paper was sprayed with clean water using a spray bottle, then acrylic ink was dropped into the water. This caused it to separate, after which the turquoise watercolour paint was dropped in.

Sprayed inktense block

Here the paper was sprayed with clean water before inktense block colours were painted and flicked on to it using a large round brush. The inktense separates and 'veins' in a unique way unlike any watercolour or ink.

Watercolour paint and artbar

Watercolour was washed on to a Not surface paper before opera pink watercolour was added and allowed to merge into the previous colour, Moonglow. Turquoise artbar was then flicked and drawn on to the surface.

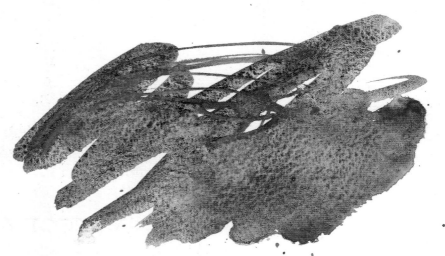

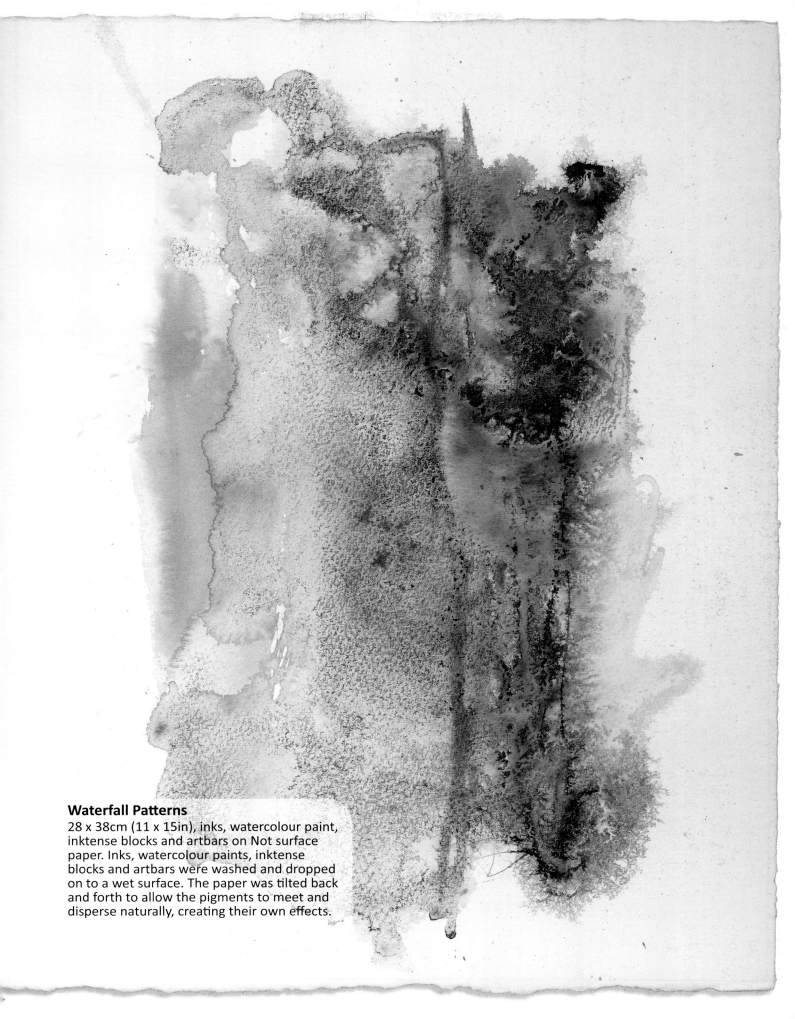

Waterfall Patterns
28 x 38cm (11 x 15in), inks, watercolour paint,
inktense blocks and artbars on Not surface
paper. Inks, watercolour paints, inktense
blocks and artbars were washed and dropped
on to a wet surface. The paper was tilted back
and forth to allow the pigments to meet and
disperse naturally, creating their own effects.

In the know

Having a basic knowledge of your water soluble materials, and where their colours fit in with one another on the colour wheel, will help you to relax and enjoy producing your artwork. In combination with simple colour charts and the short demonstrations on pages 58–61, the information in this chapter will help you to think in a more logical and organised way about how you paint.

Organisation and preparation

I am a fairly organised person. I like to know where things are. It would infuriate me if I wanted to use a certain colour but I had to scrabble about searching for it while a wet painting was slowly drying. I make sure everything is at hand and plan carefully before I begin.

This does not mean that everything must be neat and always in its place – I snap my art sticks, they become muddled up in the tins, I certainly get them on my hands and create quite a bit of mess at times – but I am prepared and organised in my approach to my painting.

At art school I was always taught that looking at, thinking about and planning our subject should take eighty per cent of our creative time, while mixing our colours and actually painting should take just the remaining twenty per cent.

Colour charts

Whenever I get a new tin of pencils or tube of colour, the first thing I do is put a sample of it on to paper. If it is paint, I put a section of it on to a small square of paper and note its name on the reverse. I find these squares of colour very useful if I am selecting an exact colour to match a sky or a flower, for example. For a whole tin of paints, I create a mini palette. This not only reminds me where I can find a particular colour in my box, but also which colours I have.

I make similar simple colour charts for my tins of pencils by blocking a small sample of each colour on to a long strip of paper in the order they first arrive in the tin. This way I can choose my colours by comparing those closely associated with each other on my charts.

As all water soluble media can be used together this is a wonderfully simple tip to get yourself organised. There is something rather relaxing about blocking in all those little oblongs of colour, then wetting them to enhance their colours into vibrant jewels. Once you do this, you will wonder why you didn't do it before!

The added advantage of having colour charts is that you can easily create an accurate colour wheel (see pages 52–53) and place any new colours you acquire on to your colour wheel in the future. This will not only help you when mixing colours, but will also allow you to accurately select the colours you own, either by number or name.

I break my inktense blocks into larger and smaller parts. The larger part is used for direct application of colour, while the smaller part is reserved for picking up colour directly using a wet brush. This simple piece of preparation allows you to work quickly with either stick or brush, and leaves the larger portion clean. Because you can leave one part in the box while working with the other, it is also helpful for quickly identifying where to put it back once you have finished.

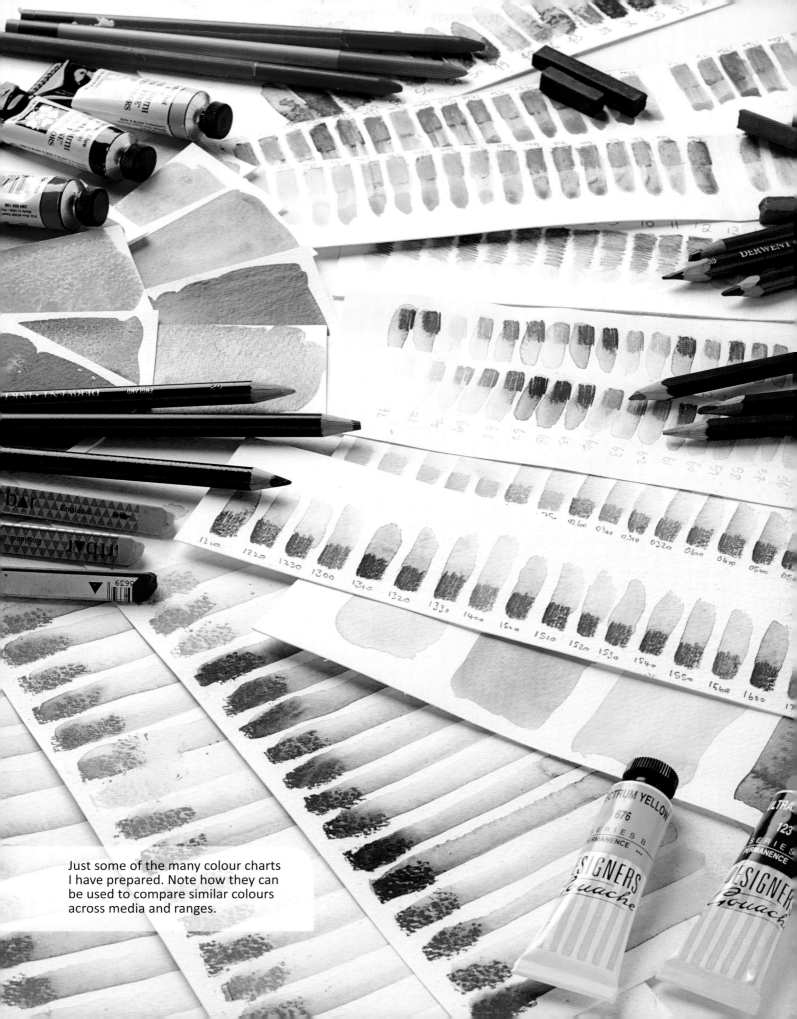

Just some of the many colour charts
I have prepared. Note how they can
be used to compare similar colours
across media and ranges.

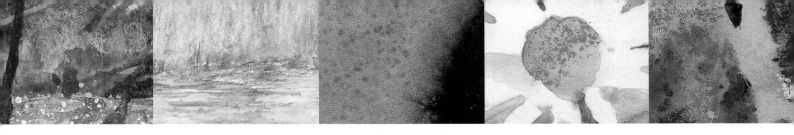

Colour

A lovely compliment I have been paid is: 'I love the way you use colour.' When drawing and painting, I think it helps to understand a bit about colour, but it is not vital as appreciation of colour is often innate. Children naturally put colour together well; they love bold bright colours and do not mind painting a purple horse or a blue cat; but as they get a bit older they seem to become embarrassed if things do not 'look real'. Peer pressure plays a part in this as well as the opinions of others – to some extent, we all like to be admired, and while painting a purple horse may get us noticed, it might not always be with admiration. Personally, I love adding purple to my darks, and think purple horses are wonderful!

I love turquoise: I use it in my paintings, I like wearing it and I like seeing it. For me, it is an exciting, uplifting colour. All of us will similarly associate certain colours with people or events that are significant to us on a personal level, and indeed when you ask people what their favourite colour is, they choose different colours – we do not all love pink!

How we use colour – where we choose to put it and how we mix or prepare it – will affect the final result, so colour is clearly important and requires some thought before you start a new piece. When I begin any painting I think about the subject and the mood I wish to convey. Is it to be bright and lively or atmospheric and subtle? Do I want a limited number of colours or lots of colour?

Over the following pages, I will help you answer these questions yourself by explaining how colours relate to one another, and how you can create vibrant combinations. This section will help you to explore the qualities of colour and give you a glimpse into the world of colour theory. Do not panic – I am not going to spend time going too deeply into technical details. I will keep things simple, because knowing the theory does not necessarily make you a better painter.

CHOOSING COLOURS FOR YOUR PAINTINGS

Colour has been demonstrated to have physical effects on us – sometimes dramatic effects. You can use these common interpretations to help you to select colours to use in your own artwork.

- Red is proven to stimulate the body's metabolism and its meanings include danger, passion, heat and of course love.

- Blue, on the other hand, is a tranquil, peaceful colour with meanings such as harmony, trust and calmness.

- Yellow is proven to cause anxiety if used in large areas, despite it being associated with joy, happiness and sunshine. It is also associated with cowardice, jealousy and hope.

- Purple is known to be a royal colour with meanings such as nobility, power, enlightenment and spirituality.

- Green is the colour associated with fertility and Mother Nature. Its meanings include renewal and money.

- Orange is associated with confidence, energy and fun.

- White is known for its association with innocence and purity.

- Black is associated with death, depression and the occult.

Opposite
Foliage with Heart
11 x 21cm (4¼ x 8¼in), artbars, inktense blocks, collage and acrylic paper on Not surface paper. Colour can be so sumptuous. I love the way the yellow jumps out against the purple and the turquoise sings alongside the orange. Experimenting with colour can be both exciting and rewarding.

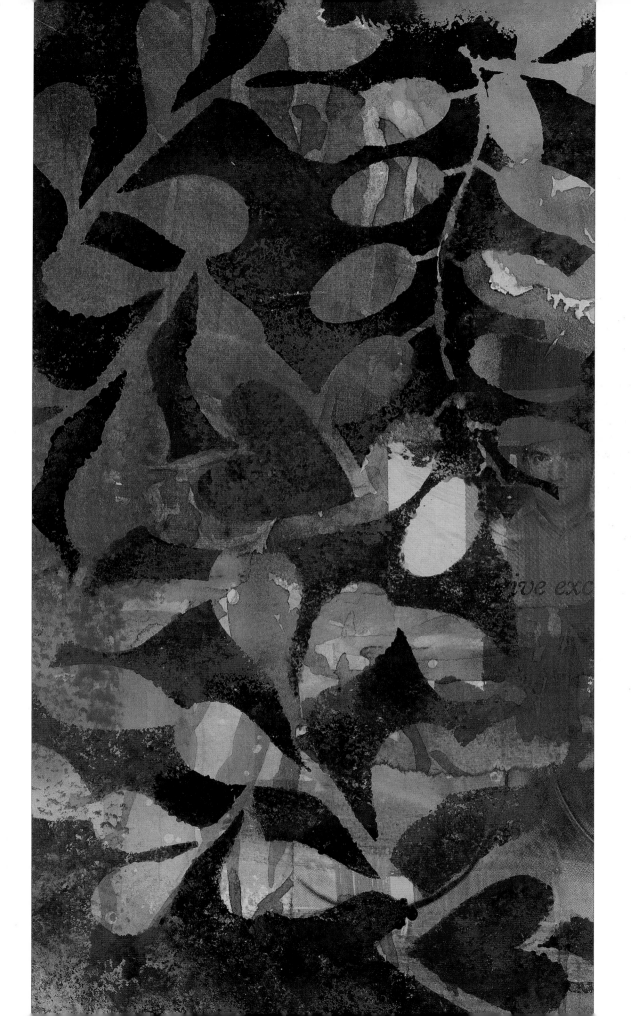

The colour wheel

The most common way of explaining about colour and mixing colour is by using a colour wheel like the one shown here. It is simple to create a colour wheel in any water soluble media, and using one as a guide will help you to work out which colours to mix together (see box on the opposite page). All the colours on the wheel are pure, unmixed colours – so depending on how many colours you have, there will inevitably be spaces in your own wheel.

Begin by placing your primary colours (see box, right) a little over halfway into the circle, then place the secondary colours between them. Once these six colours are placed, all of your other colours can be placed on the wheel by referring to your colour charts (see page 48). Place progressively lighter tones of the colour towards the centre of the wheel and progressively darker tones radiating outwards. You can now refer to your colour wheel across all media, so choosing colours, whether to use them alone or mix them, becomes so much easier. A colour wheel is probably the most indispensable tool to have beside you when painting in any medium, as it helps you to quickly see the relationships between colours.

- *Primary colours* Colours that can not be created by mixing other colours: red, yellow and blue.
- *Secondary colours* The result of mixing two primary colours together: purple, made from blue and red; orange, made from red and yellow; and green, made from yellow and blue.
- *Tertiary colours* These are the result of mixing a secondary colour with a primary colour.

The primary colours red, yellow and blue are highlighted with dotted boxes. Note that they are placed as far away from each other as possible. If you imagine the wheel as a clock face, they are at the 12 o'clock, 4 o'clock and 8 o'clock positions.

Colour mixing

There are so many wonderful colours of the various water soluble media available that you may be able to avoid mixing colours altogether, but colours will inevitably mix and blend on a wet surface. Similarly, altering the way a colour looks is important if a colour is not quite what you want. Knowing a little about colour mixing will therefore be invaluable in achieving the best results you can.

We all know that if we want orange, we mix red and yellow together, but this raises further questions – how much of each colour? Which red and which yellow? One brand of pencil or paint may look very different to another, even if they have the same name on the label, so this can be misleading or irrelevant. The crucial point to remember when mixing your own colours is simply that it is what the colour looks like which is important; not the name on the tube.

We can mix colour in a palette or on the paper. If using a mixing palette, our aim is to mix a specific colour, whereas by applying wet colour directly on to the paper or wetting a dry pigment and allowing colours to mix naturally on the wet surface, we can create lovely subtlety in our work.

Using the colour wheel

To tone down a too-bright colour, find the colour on the colour wheel and introduce a tiny amount of the complementary colour – this will be directly opposite on the colour wheel. Adding too much of this colour will create a neutral grey, but adding just a little will just tone a bright colour down.

Interesting darks can also be mixed by selecting two pure dark colours from opposite sides of the colour wheel. Correctly selecting the two colours will create fabulous blacks. For example, adding deep reds to deep greens can produce wonderful rich mixes that are particularly useful for floral subjects.

To blend a selection of colours – greens, for example – so that those colours merge together in the finished artwork, choose three or four colours along the same ring which will work together tonally but add colour variation.

Tinting

Add white to any colour and you produce a tint. Adding white changes the mood of the colour, so adding white to red changes it from being a colour suggesting danger or passion to a baby pink suggesting innocence and softness.

Adding white paint to a watercolour paint will create a heavier opaque colour which can appear more solid. You can also simply add more water to tint a colour. The transparency of the watered-down mix means that the paper glows through the paint as the pigment thins and the colour changes from red to pink. The more water that is added, the paler the colour.

There is a skill in choosing which colours you want to tint; by looking at the brightest colours (in the primary ring) you are able to select the exact colour prior to tinting. If I want a soft, mauve pink, I select a red towards the purple side of the colour wheel and choose my palest version of that colour, then add white. If I wanted a more peach pink I would choose a red towards the orange side of the colour wheel and select my palest colour, then add white.

If I wanted a more neutral or subtle tint, I would choose a darker-toned colour from the edge of the colour wheel and add white.

COLOUR HARMONIES

There are colour combinations that are traditionally considered especially pleasing. Colour harmonies always have a fixed relationship within the colour wheel, so you can choose any colour as a starting point and use any of the schemes to choose appropriate colour mixes.

- *Analogous colours* sit next to each other on the colour wheel; they usually match well and create serene mixes.
- *Complementary colours* sit opposite each other on the wheel and are considered high contrast.
- *Triadic colour schemes* use three colours equally spaced on the wheel. They tend to be quite vibrant, so it can be useful to let one dominate and the other two support.

Colour temperature

Warm and cool colours

The concept of warm and cool colours can seem a bit tricky. On the face of things, we might think that warm colours are red, orange and yellow whilst cool colours are blue and green. However, some colours do not fit this simplistic approach: what about purple, for example? The truth is that all colours can be cool or warm. A red that has a lot of orange in it – i.e. closer to yellow on the colour wheel – will be warmer than a red with a lot of blue. This is shown in the examples on this page.

Effects of colour temperature

Warm colours tend to advance forward out of the picture, while cool colours recede back into the picture. We can use this effect to help create a sense of perspective.

If you want the trees in the distance to seem a long way away, for example, use cooler colours than you use to paint the trees in the foreground. Similarly, if you are painting a street scene with figures, avoid dressing a figure in the distance in a warm red jacket, but use a cool red, or indeed avoid red altogether for distant figures. Use it instead for a foreground figure.

This is a great example of how having a colour wheel with your own colours on it can help you to see at a glance which colour might be warmer or cooler when choosing colours for your painting.

The red on the left, which has some yellow in, is warmer than the red on the right, which has some blue in it.

The yellow on the left has some red in, which makes it warmer than that on the right, which has some blue in it.

As in the above examples, the blue on the left, with red hints, is warm; while the swatch on the right is cool, with yellow hints.

Colour and medium

Colour is made from pigments, and the same pigment can be found in more than one medium. The same pigment used to make cobalt blue watercolour paint, for example, can be found in inktense blocks and acrylic paints. The binder used to hold the pigments together – water in watercolour paint, or gum arabic in watercolour sticks, for example – is what makes the difference between one medium and another, which creates the large variety of art products available.

The difference in the binder changes the way the pigment will behave, which means that the results may differ between media although the actual pigment may be the same. Knowing what is possible with the media we own can dramatically improve our creative success, so experiment with all of your media as much as possible.

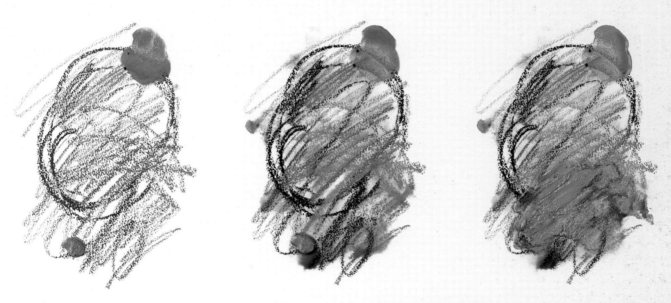

These groups of images, one worked in blue hues and the other in red hues, show aquatone pencil, watercolour pencil, inktense pencil, inktense block, artbars, graphitint pencil, acrylic paint and watercolour paint scribbled and scrawled across the paper. The leftmost images are dry, the central ones wetted and the rightmost ones wetted and agitated with the end of a paintbrush. Note how the appearance of the pigment differs across the media when dry, and how it alters when wetted.

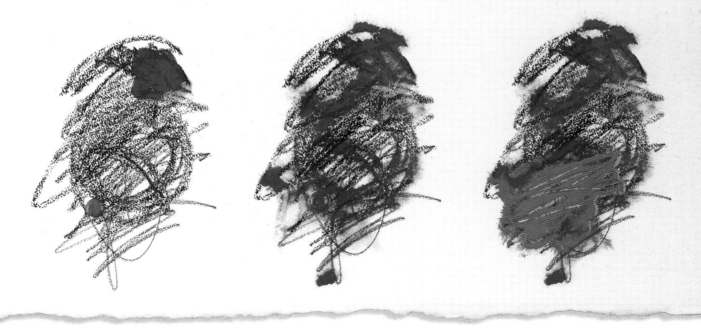

Using colour in your work

Limited colour

If I take photographs on location I am invariably disappointed when I get home and look at them because they fail to capture the feelings and impressions I had at the time from the scene. Although they might be accurate, they can not select or emphasise the colours for a successful painting for us.

Sometimes choosing a limited section from the colour wheel – an analogous colour scheme (see page 53) – can result in a very atmospheric drawing. In the example below, I have chosen a small range of sepia-yellows in a variety of tones. These are used for everything from the gondolas to the sky.

Venice
20 x 18cm (7¾ x 7in), graphitint pencils on Not surface watercolour paper. Drawn on location using a limited number of pencils, this sketch enabled me to concentrate more on the tonal values and less on the hues of the colour.

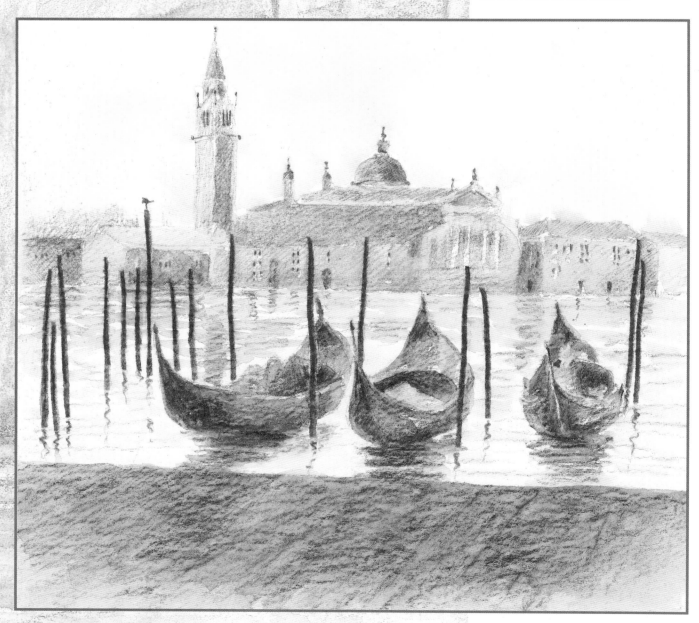

Complementary colours

Complementary colours are those that sit opposite to each other on the colour wheel (see page 53). Placing them next to each other in a painting creates fabulous impact.

This does not mean that we always have to use them at their brightest. Complementary colours can be used in subtle colour mixes as well as full vibrant colours.

Using colour in a dynamic way is not only exciting and unique; it can also help you to communicate what you feel about your subject. It is the interactions between the colours within the painting that are important. It is always necessary to be aware of the colour combinations you use, their tonal values and the overall feeling they are creating.

Evening Light
20 x 18cm (7¾ x 7in), inktense and artbars on watercolour paper. Almost every colour on the colour wheel has been used in this little painting. Of course, this is nothing like the actual colours I saw at the time – even if you prefer to work in a more naturalistic way, you will probably want to enhance your painting at some time.

Subtle colours

Imagine a misty morning where all of the colours are muted, soft and slightly out of focus. The mood of the scene changes totally from the same view in bright sunshine. Just as the conditions of the day can change our landscape view, so we can alter the mood of our painting by using subtle colour mixes and combinations. The exercise on these pages shows a simple cat drawing using subtle watercolour pencil hues.

MATERIALS USED:

Watercolour pencils: ultramarine (29), light violet (26), cobalt blue (31), sky blue (34)

Not surface watercolour paper, 300gsm (140lb), 25.5 x 23cm (10 x 9in)

Large round paintbrush

Masking tape and board

1 After setting out a border of masking tape, sketch out the basic shapes of the cat using the watercolour pencils ultramarine, light violet, cobalt blue and sky blue. Lightly block in the areas by rubbing the sides of the watercolour pencils over the area, picking up the texture of the paper. You can overlay areas with more than one light colour to create interesting effects.

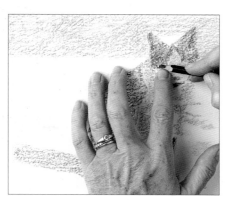

2 When blocking in the darker areas, be more careful not to go over the lines, in order to maintain the definite shapes.

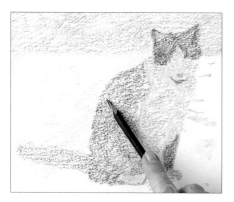

3 Overlaying the basic shapes very lightly with a darker colour will help to create subtlety by binding the various parts of the picture together.

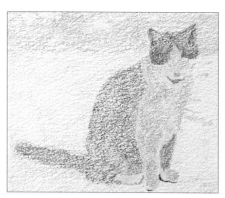

At this point, the basic picture of the cat is complete – the tones of the watercolour pencils give a wonderful subtle feel to this cat.

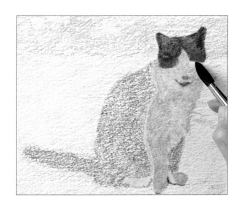

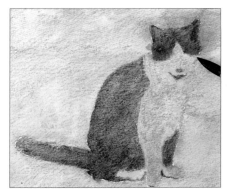

4 Using a soaking wet large round brush, carefully wet the blocks of colour with a light touch. Do not scrub or brush the colour around; try to keep the areas fairly separate.

5 If you want a softer, more subtle edge to an area, touch the brush between the areas to let them bleed into one another.

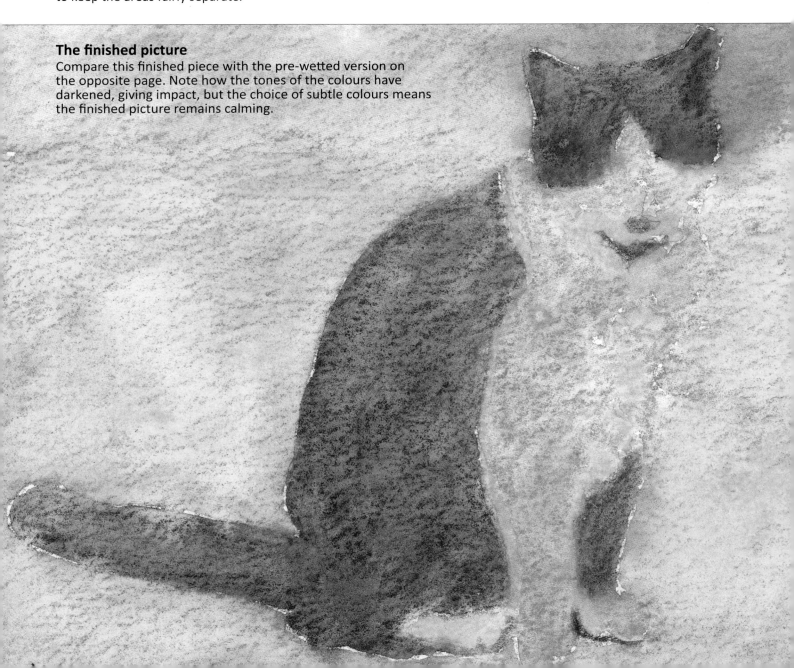

The finished picture
Compare this finished piece with the pre-wetted version on the opposite page. Note how the tones of the colours have darkened, giving impact, but the choice of subtle colours means the finished picture remains calming.

Creating the 'wow' factor

Altering the colours we use in any painting is what makes the difference between painting the obvious and creating added interest. Providing we choose our colours with care and stick to the correct tonal values, the sky is the limit.

Using complementary colours is always a favourite of mine, but any combination can be exciting – think of Andy Warhol's famous screen prints of Marilyn Monroe. You might like to have a look at some of those colour combinations and use them to inspire your own work.

MATERIALS USED:

Watercolour pencils: ultramarine (29), light violet (26), cobalt blue (31), sky blue (34)

Artbars: tertiary orange (A04), duck egg blue (A31), midnight (A60), process magenta (A08), iris (A10), spice (A40), primary red (A05)

Not surface watercolour paper, 300gsm (140lb), 25.5 x 23cm (10 x 9in)

Large round brush

Spray bottle

Masking tape and board

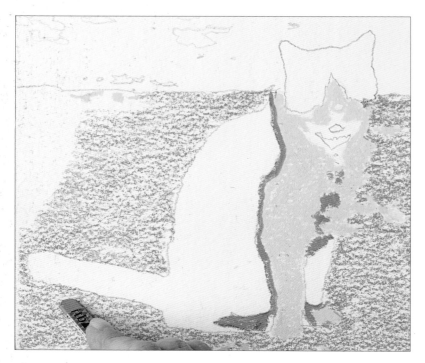

1 After setting out a border of masking tape, sketch out the basic shapes of the cat using the watercolour pencils ultramarine, light violet, cobalt blue and sky blue. Block in the areas using artbars, with light pressure for lighter areas or places you wish to overlay, and pressing more firmly for more definite, darker areas.

2 With the shapes in place, begin glazing with overlaying colours. Use complementary colours – those opposite one another on the colour wheel – for a striking effect.

 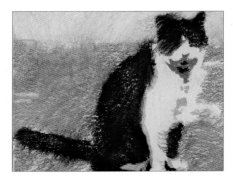

3 Use the spray bottle to lightly spray the background, shielding the cat with your hand. Allow the colour to develop with the water.

4 Lightly spritz the cat with the spray bottle, and tilt the board a little to encourage the colours to merge and blend.

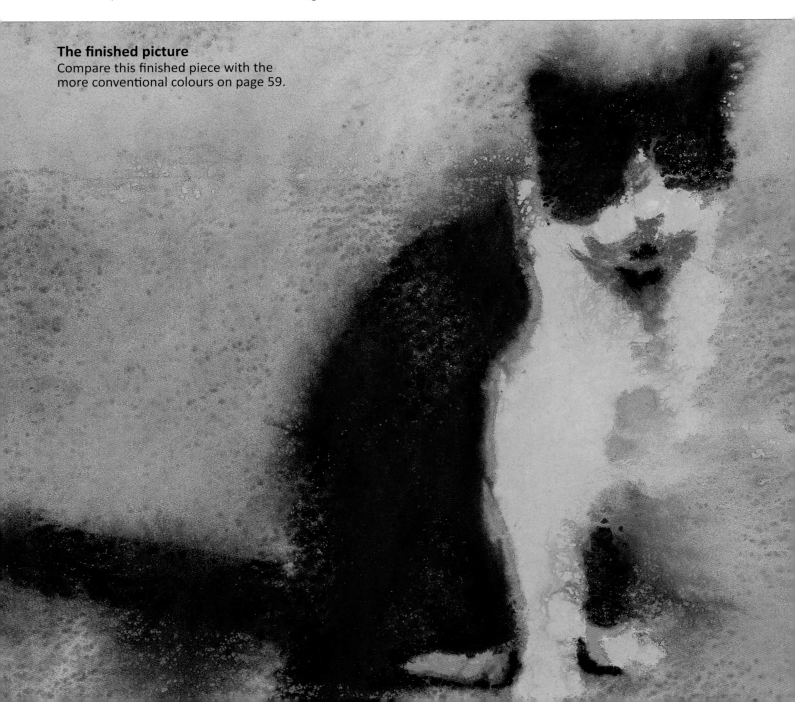

The finished picture
Compare this finished piece with the more conventional colours on page 59.

Placing pure colour

Impressionism was a nineteenth-century art movement whose practitioners are best known for their use and placement of colour. They were always trying to paint with spontaneity, capturing sunlight, colour and reflected colours.

The Impressionists preferred to paint outdoors when possible – indeed they often worked in the evening or twilight to capture fleeting light. In their paintings made *en plein air* (outdoors), shadows were boldly painted; with the blue of the sky reflected on to various surfaces, giving a sense of freshness previously not represented in painting.

They often used short, thick strokes of opaque paint in order to quickly capture the essence of the subject, rather than its details. Colours were applied side by side with as little mixing as possible, creating a vibrant surface where the optical mixing of colours occurs in the eye of the viewer. Greys and dark tones were produced by mixing complementary colours, and pure Impressionism avoids the use of black paint altogether.

Painters throughout history had occasionally used these methods, but Impressionists were the first to use them all together. The colours and feel of my painting *Evening Light* on page 57 were very much inspired by the Impressionists.

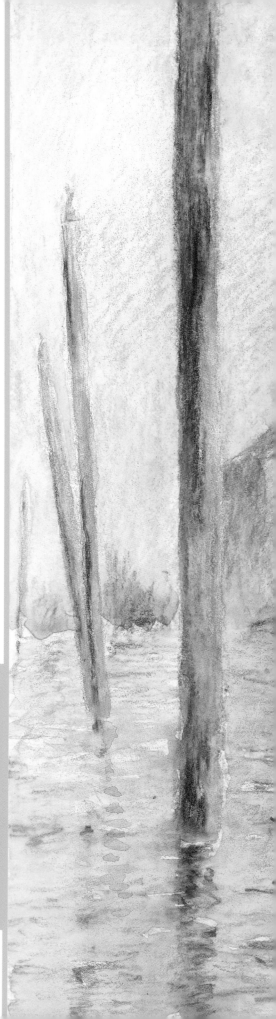

After Claude Monet
28 x 28cm (11 x 11in), watercolour pencils on smooth HP watercolour paper. *The Grand Canal*, Venice, by Calude Monet (1840–1926) was produced in oil on canvas in 1908, and is currently in the Museum of Fine Arts in Boston, USA. This is my version, produced using watercolour pencils. Studying how others use colour is a wonderful way of learning. For centuries, artists have copied and reinterpreted the Masters' work in order to improve their own techniques and understanding. I am no different and over the years have copied many of the Impressionist works, which I greatly admire.
I find myself wondering how Monet might have used artbars or graphitint pencils if he were alive today. Using watercolour pencils on the dry paper, I scribbled and overlaid colour wherever I saw it, then gently wet it using my large round brush.

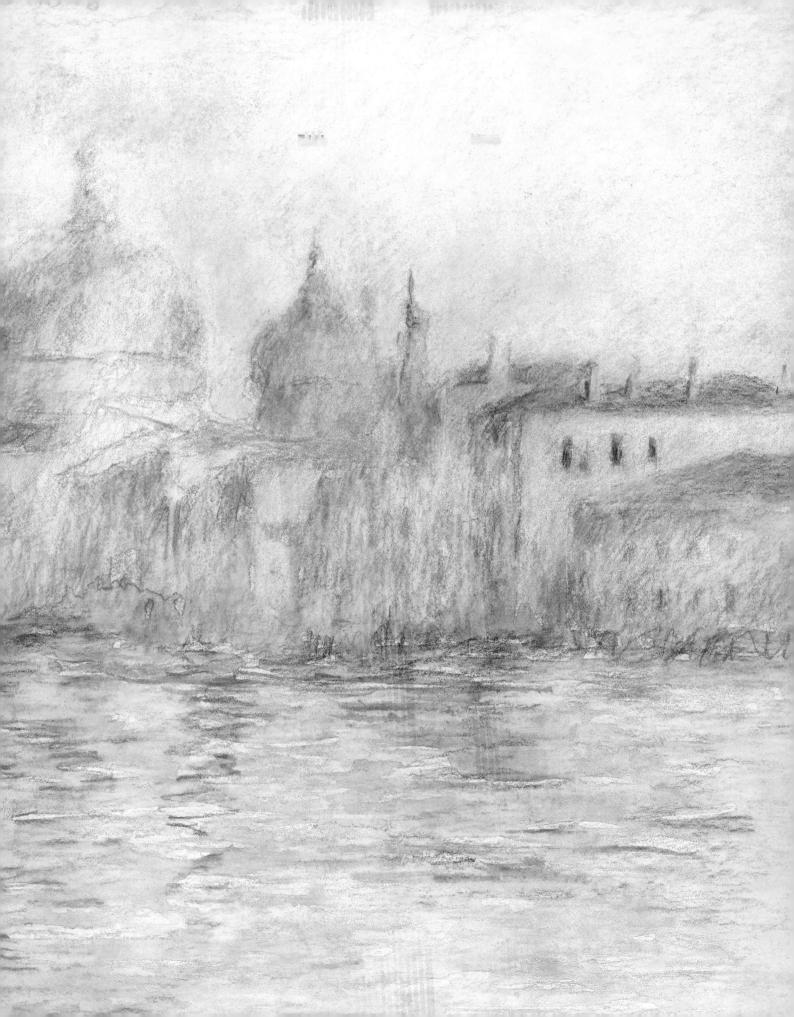

Exaggerating colour

If you want to enhance colours, you have to be able to see them in the first place. A good exercise is to gather three white objects – perhaps a jug, a bowl and a vase – place them on a white sheet of paper against a white background and light them from the side with a spotlight.

Now relax, and look at the display. Let your eyes adjust to the tones, and slowly you will begin to notice colours. They will be very subtle at first and then you may find a feeling of artistic excitement as you notice a strong purple in the shadows, a pale yellow glow on the jug or perhaps subtle pinks on the vase.

The light will reflect from each item as well as the surface and the background – all objects have an effect on one another. Reflected light can be very subtle indeed. Once you begin to see the colours, the trick is to enhance them in your painting.

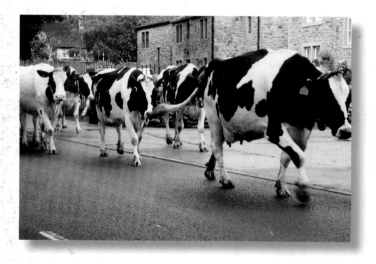

Off to Milking
22 x 19cm (8½ x 7½in), inktense blocks and artbars on Not surface paper. This example shows you how I see the colours in the photograph above. You might think: 'Turquoise on a cow? Surely not!', but if you really look at the photograph, relax and let your eyes absorb the colours, you will see them – all I have done is enhance them.

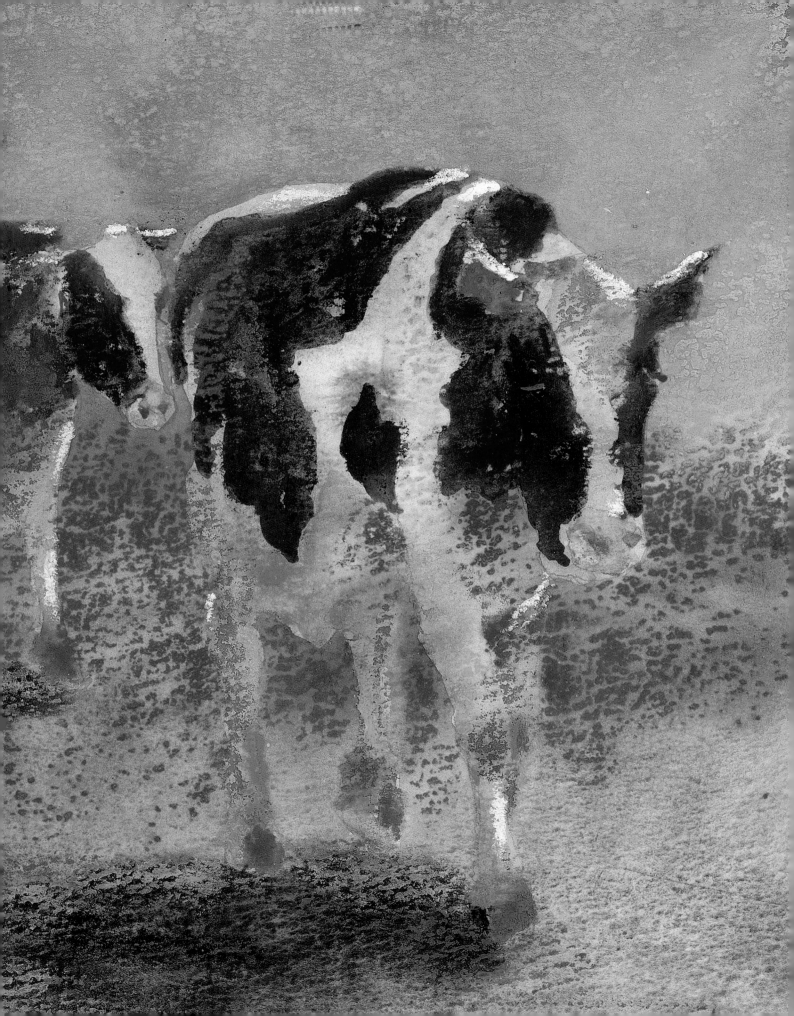

Making an impression

Whatever we paint, we all want to achieve success and we all want to impress. From our first proud pictures stuck on the refrigerator door, to making a card for someone special, a painting is our unique creation. Placing one colour next to another and allowing the pigment to move across the paper is just part of this process.

From the first cave drawings discovered, which date back nearly 40,000 years, man has had a need to express himself. This creativity of expression is one of the things that separates us from other creatures.

Dynamic doodles

If we hold a pencil as if we were going to sign our name, our fist is inevitably placed firmly on the surface and we are only able to move the pencil about 2.5cm (1in) or so, before the need to lift or slide it along the paper in order to continue working.

If we instead hold our pencil higher up, leaning on the paper with just our little finger for support, we are able to move more freely and create longer, more descriptive, strokes. If we stand to draw, or use an easel, our lines can be even more free and our strokes bolder and more expressive.

Some pencils lend themselves to sketching more than others. Graphitint are pencils made of graphite with a hint of colour, so using them feels very much like drawing with an ordinary pencil. Used on a smooth paper, very fine details can be achieved; while using them on a Not surface paper will result in a more textured finish.

Before wetting, the colours are so subtle that using a selection of colours within a single drawing needs a certain amount of organisation. I always separate pencils I have used within each drawing so I know which one to use again. My colour chart is also vital to ensure I choose the right colours, as their full effect is only evident once I wet the drawing later.

MATERIALS USED:

Inktense pencils: outliner

Artbars: topaz (A14), tertiary orange (A04), popcorn (A34)

Smooth HP watercolour paper, 300gsm (140lb), 25.5 x 23cm (10 x 9in)

Spray bottle

Masking tape and board

Kitchen paper

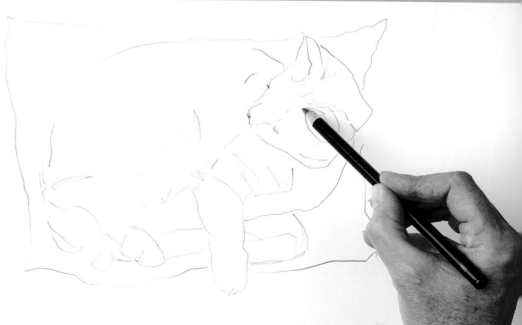

1 Use the inktense outliner pencil to draw the basic shapes. This pencil is non-soluble, so it will remain strongly visible even if wetted. Hold the pencil further up than you normally would, in order to create a loose and dynamic quality.

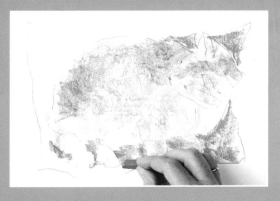

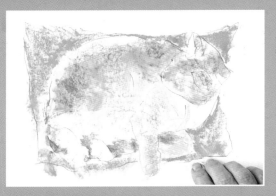

2 Use the flat sides of the artbars to block in the main shapes with a loose, sketchy feel.

3 Use the spray bottle to allow the colours to blend and develop. If the colour flows too far, use a little kitchen paper to soak up the excess.

The finished picture

These results would have been quite different using a Not or Rough surface watercolour paper. It is often a good idea to try various colour and paper combinations using the same subject.

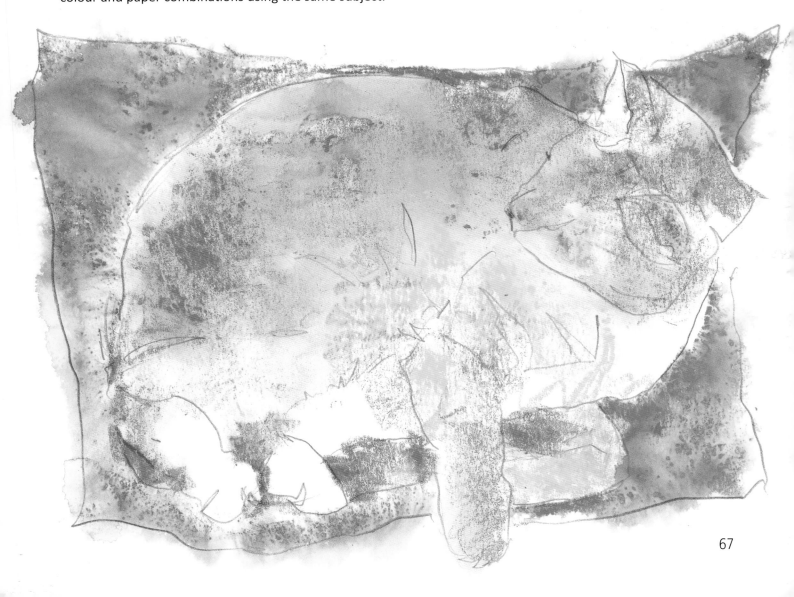

Sketching techniques

The various types of water soluble pencils have different properties and the finished results can be surprisingly different depending on the ones you choose. The three exercises on the following pages are designed to highlight the contrast between media, by using the same theme throughout.

Graphitint pencils

Graphitint pencils are particularly suited to sketching techniques as these pencils feel and behave very much like graphite pencils. However, once water is applied, a wonderful burst of colour emerges that enhances the original drawing.

MATERIALS USED:

Graphitint pencils: aubergine (03), chestnut (13), meadow (10), dark indigo (04), ocean blue (07), autumn brown (17)

Large round brush

Smooth HP watercolour paper, 300gsm (140lb), 10 x 15cm (4 x 6 in)

Masking tape and board

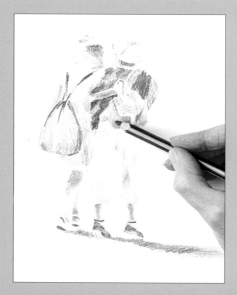

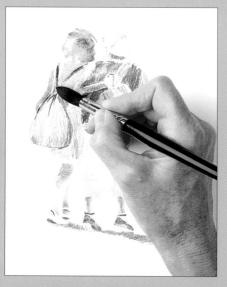

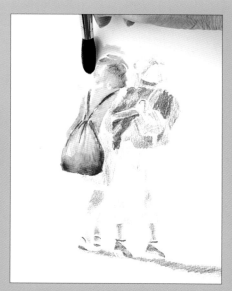

1 Once you have secured the paper in place on your board using masking tape, block in the basic shapes using the graphitint pencils.

2 Using a wet large round brush, carefully wet the blocks of colour to allow the colour to spread. Leave dry paper for areas you wish to remain white, and to keep colours apart. If you wish them to blend together, use the tip of the brush to create a bridge between two wet areas that allows the colours to meet and merge.

3 Create a background by picking up colour from your paper palette and laying it in around the figures.

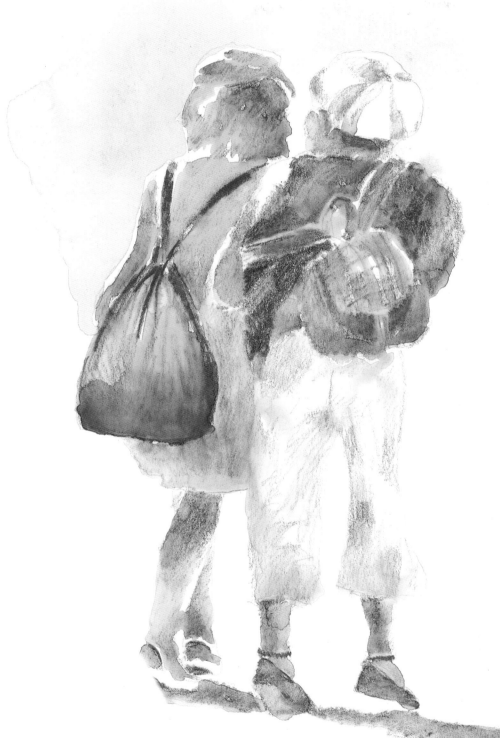

The finished picture
These pencils leave a lovely gritty graphite residue when used with sketching techniques and wetted. Add more water to dispel this effect, and less to retain it.

Watercolour pencils

Being pigment based, watercolour pencils feel soft against the paper and are easy to sketch with. Blending and overlaying colours is simple and their opacity ensures a gentle, almost romantic, result. Inktense pencils feel similar but their colours are more vibrant and transparent.

 The watercolour pencils I have used here can be substituted for inktense pencils – or a mixture of both.

MATERIALS USED:

Watercolour pencils: ultramarine (29), chocolate (66), turquoise blue (39), rose pink (18), terracotta (64), copper beech (61), imperial purple (23), magenta (22), scarlet lake (12), light violet (26)

Large round brush

Not surface watercolour paper, 300gsm (140lb), 20 x 30cm (7¾ x 11¾ in)

1 Block in the basic shapes using the watercolour pencils.

2 Using a wet large round brush and a light touch, pick out the shapes to allow the colour to develop. These pencils change colour quite markedly when wetted, so keep a paper palette nearby to allow you to alter the colours as you work.

3 Pick up colour from your paper palette with a wet brush and use the entire brush to apply a background, leaving white spaces around the upper left parts of the figures to create a sense of light. Copper beech, ultramarine and imperial purple were used for this mix.

The finished picture
Using plenty of water produces lovely drying lines on the edges of the shapes, yet still retains the wonderful textures created by the paper surface.

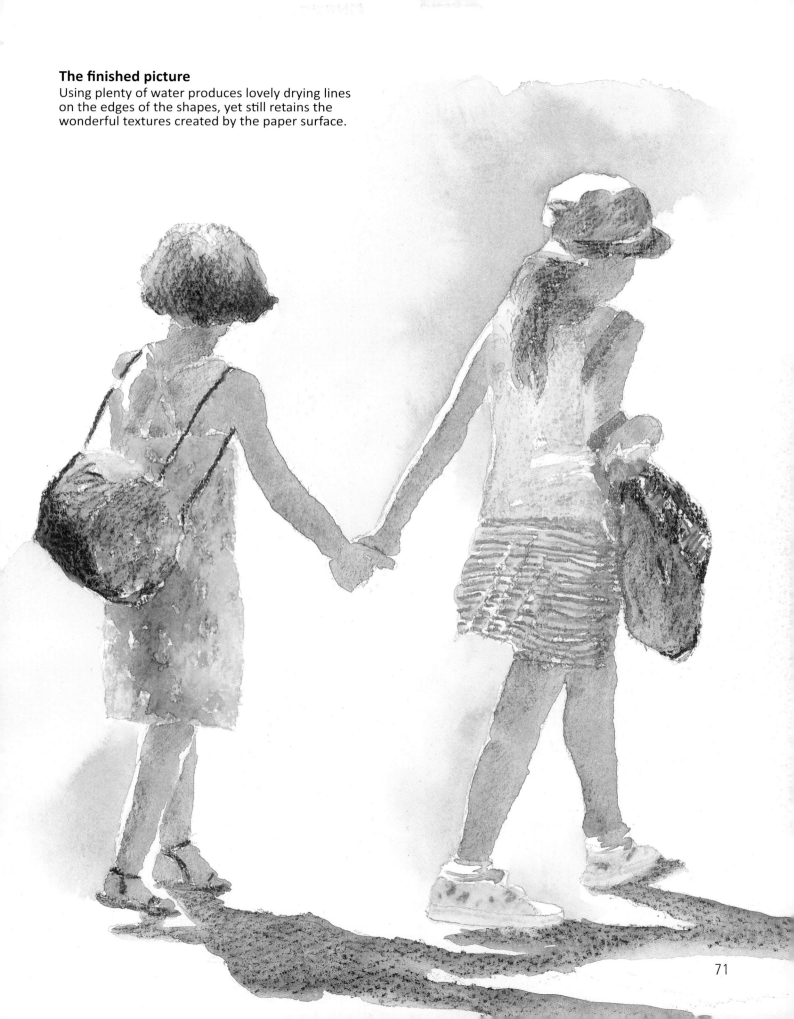

Inktense blocks and artbars

Inktense blocks and artbars are ideal for a looser, more dynamic approach to sketching, where details are unimportant but sumptuous bold colour is required. Large areas can be covered quickly for an intuitive approach resulting in a more painterly finish.

MATERIALS USED:

Inktense blocks: deep indigo (1100), turquoise (1215), fuchsia (0700), madder brown (1920), dusky purple (0730), baked earth (1800)

Artbars: praline (A41), violet earth (A42), soft lavender (A26), dark indigo (A59)

Large round brush

Not surface watercolour paper, 300gsm (140lb), 20 x 30cm (7¾ x 11¾ in)

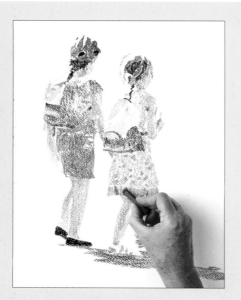

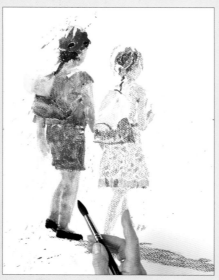

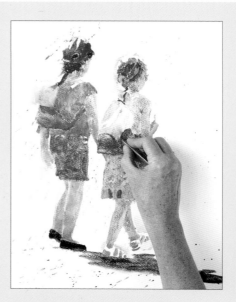

1 Use the artbars and inktense blocks to block in the basic shapes.

2 Use a wet large round brush to develop the colours, area by area. After you have activated the colour with the brush, a little of the colour will be picked up in the brush. You can use this to add spatter effects by tapping the brush sharply with your finger. If you dilute the colour by dipping the brush into clean water, you can add some soft backgrounds with gentle strokes of the brush.

3 Develop the background by combining the spattering and soft background techniques, then leave the work to dry. Once completely dry, you can use the artbars to pick out additional highlighting or shading for detail.

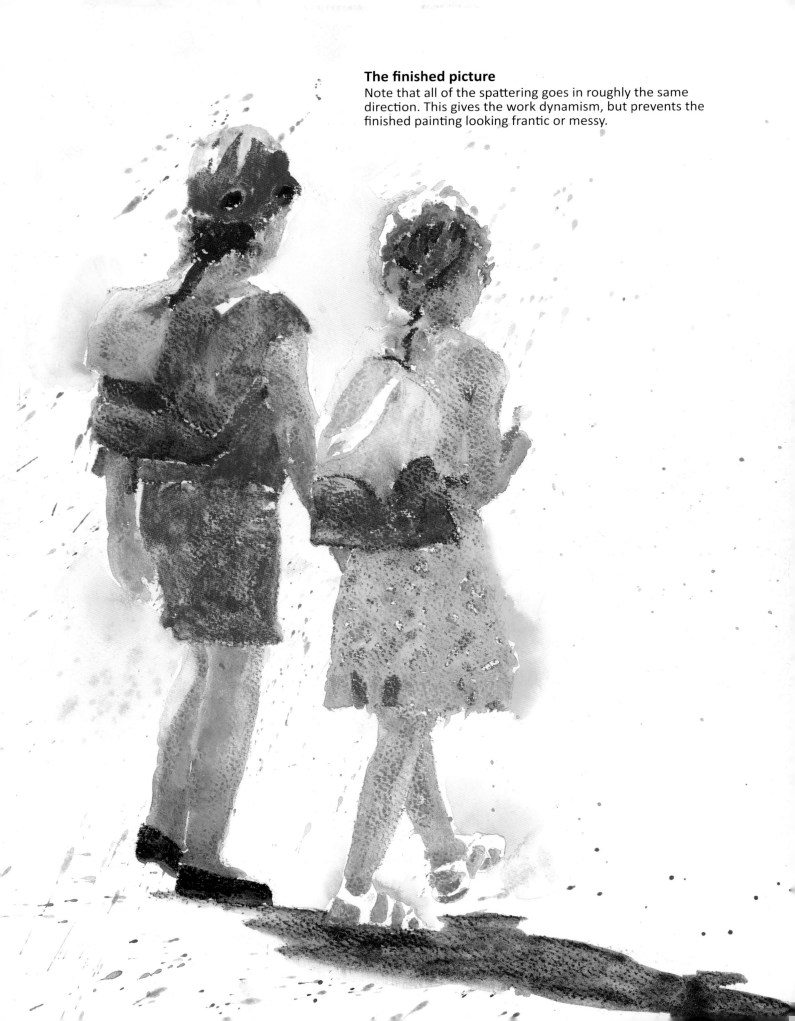

The finished picture
Note that all of the spattering goes in roughly the same direction. This gives the work dynamism, but prevents the finished painting looking frantic or messy.

Using other media with pencils and sticks

Mixing the media we use in a painting can add another dimension to our work as well as creating textures and different effects. Providing the media mix with water, anything is possible.

Using watercolour paint in your artwork

The painting shown opposite is built up in many layers. I began by masking out all of the flowers using masking fluid and a brush. Once dry, I used clean water to wet the paper and began to drop bright yellows and blues on to the painting, allowing the colours to merge but covering all of the white unmasked paper. This was a good time to drop in some reds or purples under the background flowers.

Once thoroughly dry I then began to freely scribble into the background using a number of green, yellow and blue inktense pencils. At this point, I removed the masking from the background flowers which will have the darkest colour added on to them later.

Using a spray bottle, I then sprayed water on to the painting, causing the inktense to begin to dissolve, brighten and seep into some of the petals (you can enhance this effect by dropping in more watercolour at this point if the colours are not seeping enough). I also used the sandpaper block to scrape some green speckles on to the wet background.

Once dry I removed the rest of the masking fluid and checked that all of the background flowers were covered in some colour, then I enhanced the foreground flowers using either inktense or watercolour as appropriate.

Lastly I painted the flower centres and scraped some bright orange inktense on to the sandpaper block, allowing the small shavings to fall on to the wet centres. Once dry I adjusted and added the tiny dark sections to finish.

Summer Daisies
22.5 x 19cm (8½ x 7½in), watercolour paint and inktense pencils on Saunders Waterford high white Not surface paper, 300gsm (140lb).

74

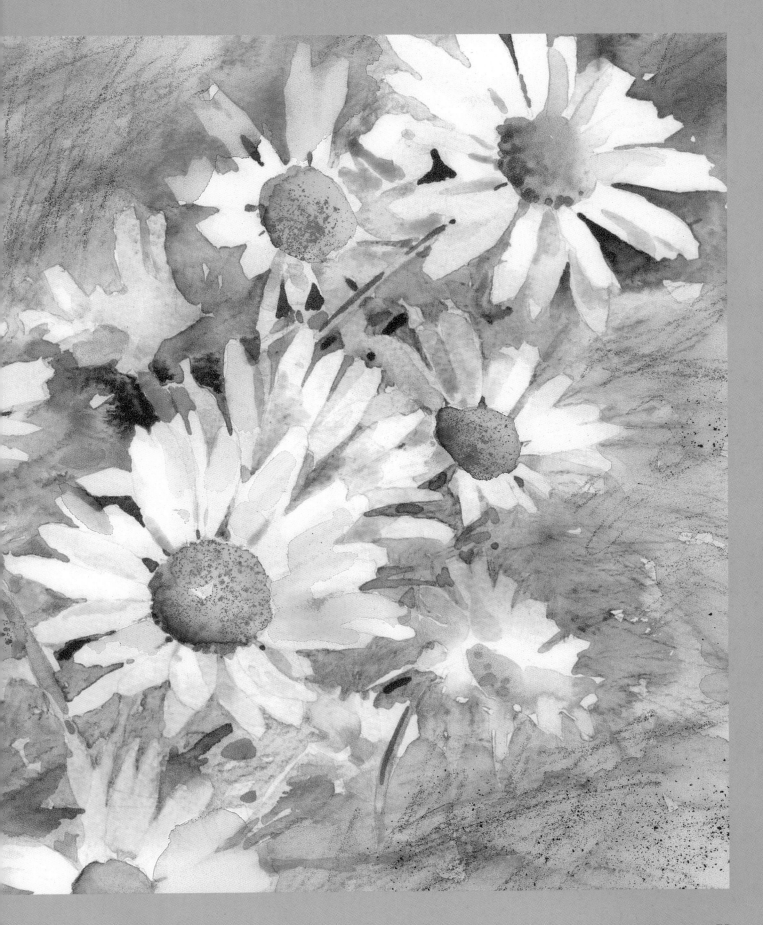

Using inks in your artwork

For the painting opposite, I used an orange inktense pencil to draw the shape of the cockerel on to watercolour paper before randomly wetting the paper on the diagonal in the direction that I planned the cockerel's head would be facing. This was intended to suggest movement as well as create a background area in similar colours to the subject. Building a painting up using this technique is relatively simple and avoids having to consider a background at a later stage.

Once the paper was wet dropping in the vibrant coloured inks was the fun bit – allowing the colours to race across the paper is so exciting! I dropped in red and yellow using the dropper in the head of the bottle lid, then used my large round brush to splash and flick similar colours from the inktense blocks on to the wet colour. This first stage needs to dry completely before the cockerel is painted on top.

For the cockerel himself, I began by using inktense blocks for the shape of the beak, then worked towards creating the shape of the head. I left small gaps so that these sections remained clearly defined. Once these areas had been established, I dropped in more ink, which created lovely textures, as well as flicking the inks in the direction of the feathers.

While this was still wet, I scraped graphitint pencils over the sandpaper block to create dark speckled sections, then allowed it all to dry. Finally, I used artbars to add the lighter textured areas, the highlights and the eye details, wetting those areas which needed to appear a more solid colour.

Opposite
Daybreak
35.5 x 56cm (14 x 22in),
watercolour paint and inktense
pencils on Bockingford white Not
surface paper, 300gsm (140lb).

76

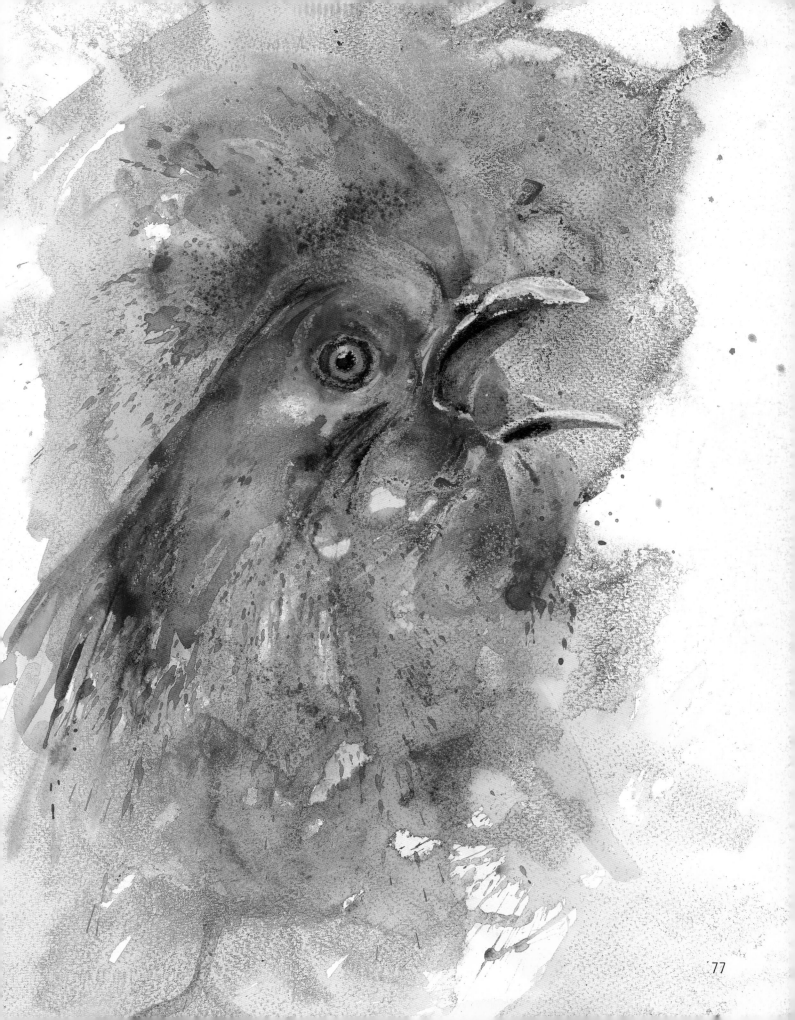

Using gouache in your artwork

Like watercolour, this medium is ideal to use with water soluble pencils. For the example opposite, I used graphitint to sketch the figures and place the boat masts. I particularly enjoy sketching with graphitint as it is so like a graphite pencil, as opposed to other pigment-based water soluble pencils. I wanted to create a sense of movement, so I sketched and shaded the figures but left the sails as soft outlines. I wanted the light to appear to shine through the sails, despite the rain, so it was necessary to add strong contrasts in the foreground to achieve this. I also sketched the foreground texture and the boats.

I began the wet stage by diluting gouache for the sails. This needed to be very dilute as I wanted the paper to show through it to represent light. I started with the central area and as soon as the paint touched the graphitint, I cleaned out my brush and allowed the sections to merge, adding gouache where I felt it needed it. I painted the second figure then linked them together with the boats. I next moved on to the foreground figure – the one pulling the boat – leaving tiny gaps to prevent all the colours merging completely. This ensured that the shapes remain distinct but linked. I added the boat at the same time.

Returning to the background of the painting I added the distant figure and the boat behind the main figures. I then used clean water to wet the entire foreground area and used the sandpaper block to sprinkle graphitint on to the surface, as I wanted lots of texture in the dark areas.

Once it had dried, I darkened a few areas, mainly the dark foreground, using gouache. This successfully went over the graphitint speckles without losing the texture. I decided to add some turquoise artbar where the graphitint turquoise had all but disappeared, then added some dark sections and a few tiny light areas.

I next used a spray bottle and sprayed the painting. This has the effect of softening edges and giving the suggestion of movement. It is not without risk, as over spraying will lose too much definition, but a gentle spray works wonders! Finally, after it was dry, I flicked gouache in a diagonal direction to suggest the onset of rain.

Opposite
Just Starting to Rain
27 x 36.5cm (10½ x 14½in), graphitint pencils, artbars and gouache on Saunders Waterford high white Not surface paper, 300gsm (140lb).

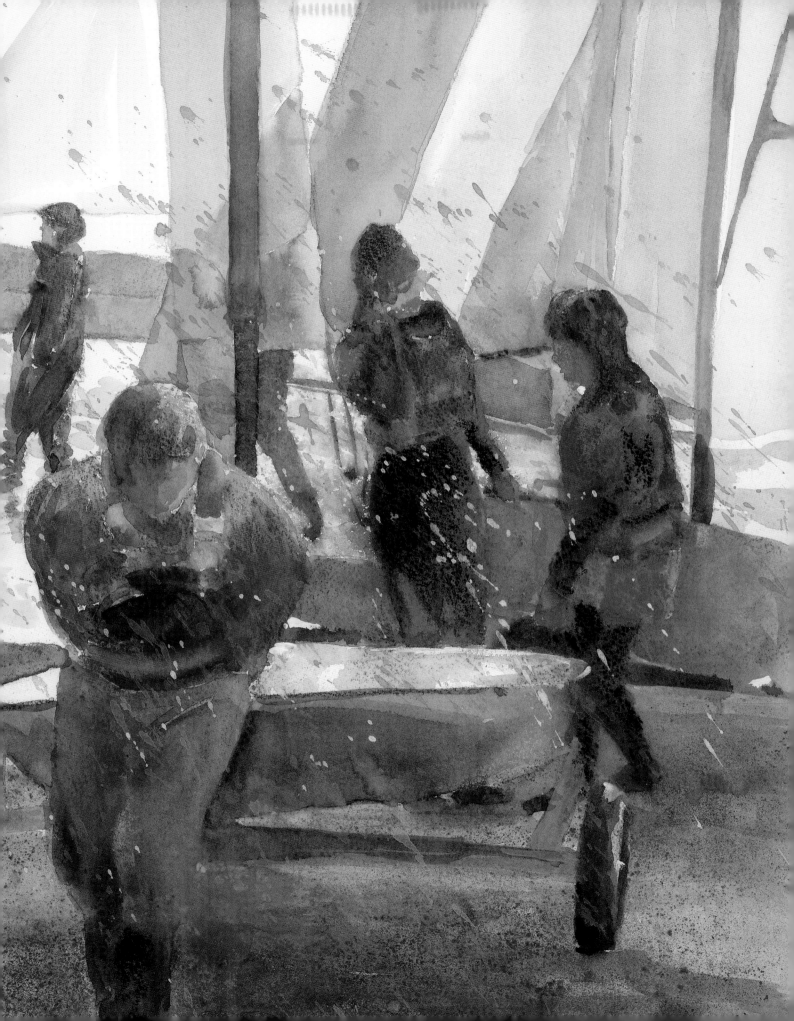

Using acrylic paints in your artwork

Acrylic paints can be used with water soluble pencils as a base to put the pencils on, or to cover areas of bold thick colour.

I love the whole subject of this painting, for me it sums up dads. I wanted the background harbour scene to be bold blocks of colour although I did not want it to distract from the family group. I began by using artbars to position the subject and background harbour walls; applying thick, sumptuous artbar colour for the figures and turning the block on the side for the water. Once the painting was entirely covered in pigment I liberally sprayed the picture with clean water, then tilted it back and forth horizontally. This created some wonderful effects, particularly in the water and the foreground, but sections of the figures also melted into the background.

Once dry I placed the picture on an easel and stepped back from it to assess what I needed to do next. I began to place the background shapes using acrylic paints. These were used to suggest the boats as well as to silhouette the father's shirt against the harbour wall and his head against the lighter awnings.

The bright orange and green 'islands' of artbar left to suggest the boys' shoe straps needed no altering, but the turquoise shorts were too similar to the water so I painted green acrylic on to them. I added some white acrylic highlights to the water, especially near the figures and lastly added a few artbar highlights to the figures.

The acrylics add an attractive solidity to the softer initial painting and enhanced the work done with the artbars.

Opposite
My Turn Now Dad!
32 x 28cm (12½ x 11in), artbars and acrylic paints on Saunders Waterford high white Not surface paper, 300gsm (140lb).

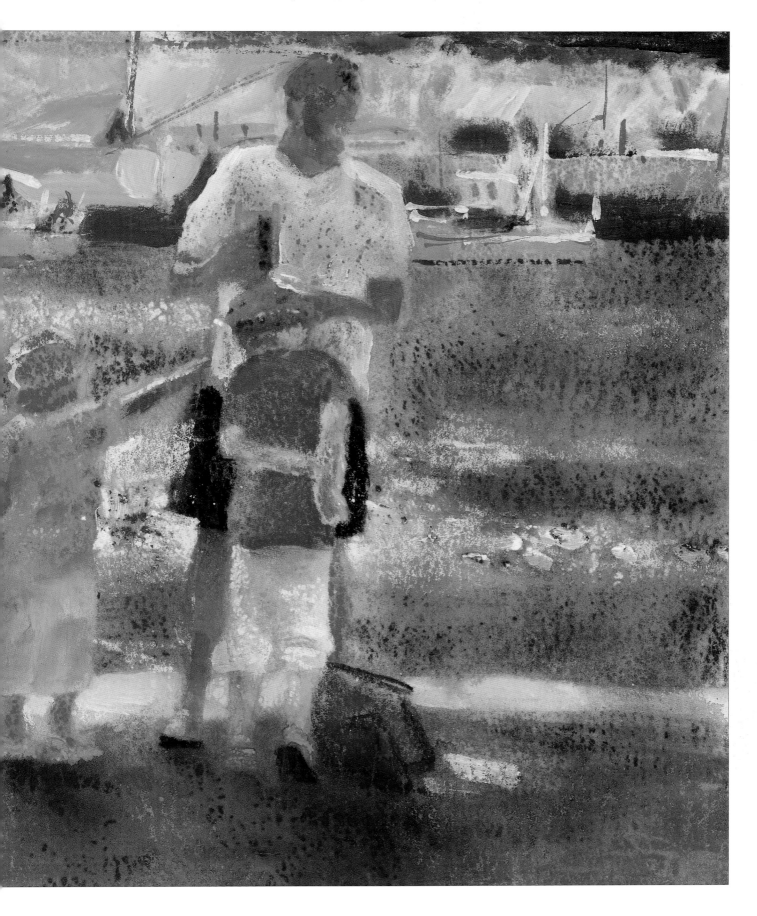

Here, or Further Along?

Some pigments have naturally occurring properties which create textures for us, without us having to do very much other than placing the paint on the paper. These pigments either granulate or flocculate. Granulating pigments settle into the dips in the paper, so the rougher the paper the more evident the granulation. These textures are barely noticeable on smooth HP paper. Flocculation occurs when pigments are attracted to each other and cling together forming tiny clumps, creating a gritty texture evident on all surfaces, even on a smooth mixing area when the paint is still wet.

Choosing particular colours with these properties can enhance the effects we can achieve within our painting for very little effort.

1 Secure your paper to the board and make a border around it using masking tape, then draw out the basic shapes of the figures using a 2B pencil. Roll your putty eraser over the pencil lines gently to soften them.

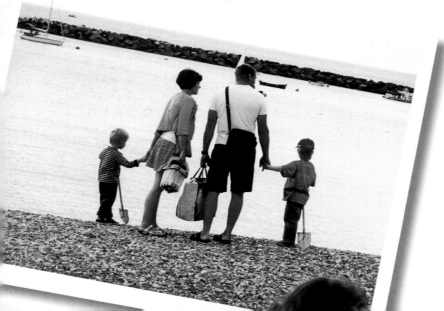

The source photograph for this painting.

2 Use the masking fluid applicator to apply tiny spots on to the woman's skirt and to protect the straps of her shoes.

3 Once the masking fluid is dry, wet the whole paper with clean water using the Golden Leaf brush. Drop in a wash of phthalocyanine blue (green shade). Near the shoreline, introduce a little cobalt teal. Clean and dry your brush and lift out the light areas of the woman's top. While the paper is still wet, introduce quinacridone gold over the shoreline, then allow the painting to dry.

4 Once the painting is completely dry, use the large round brush to paint the woman's head with a skin mix of iridescent copper and quinacridone sienna for the skin. Use the point of the brush to drop in moonglow to give the hair shape.

5 Use cobalt teal to paint the left-hand side of her top. Once established, touch the point of the brush into the wet hair, and allow the colour to bleed downwards to shade the top.

6 Leaving small gaps of dry paper to keep the areas of colour separate, or lightly touching them to allow them to bleed, use phthalocyanine blue (green shade) to paint her skirt and moonglow for her handbag. Extend her arm using the same mix of iridescent copper and quinacridone sienna.

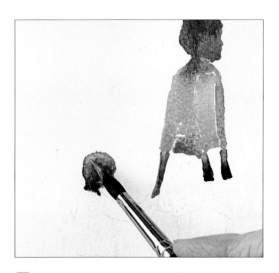

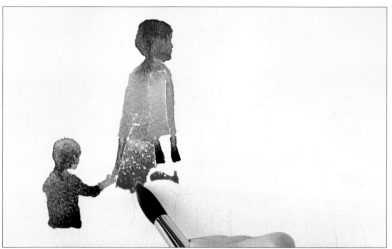

7 Paint the little boy's head with the same mix and moonglow, then use the pointer to touch interference lilac to the top of his head to create a highlight.

8 Using French ultramarine, paint his top and use the skin mix (iridescent copper and quinacridone sienna) to join his hand to his mother's. While the paint is wet, wash over her skirt with quinacridone coral. Use the same mix to paint the skirt behind the bucket handle and the little boy's spade, using the point of the brush.

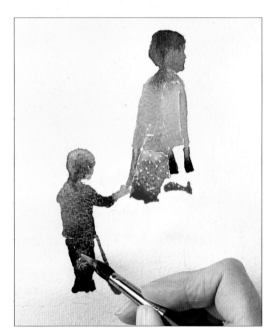

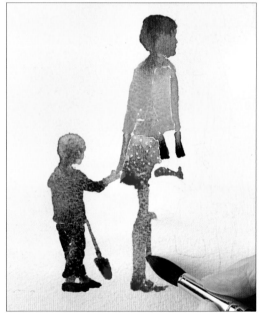

9 Touch the point of the brush to the join between the little boy's jumper and spade handle, then carefully paint his trousers with moonglow. While they are wet, use the pointer to add highlights with interference lilac.

10 Finish the little boy by painting his shoes with moonglow and his ankles with the skin mix, then extend the skin mix down the woman's legs and arm, adding a hint of moonglow wet in wet for her shoes and interference lilac for the highlight on the back of her legs.

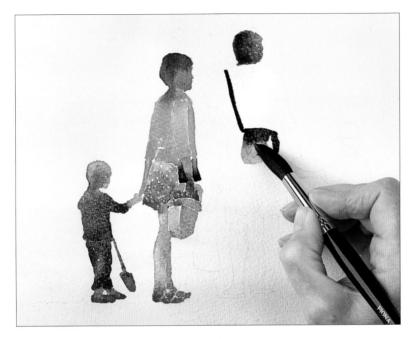
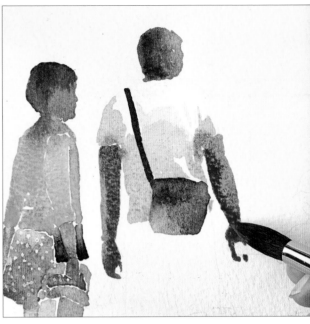

11 Finish the woman by painting the bucket handle with quinacridone gold, and the bucket itself with a mix of French ultramarine and opera pink. Paint the man's head with the skin mix, adding moonglow to suggest hair and shape his head. Use pure moonglow to paint his bag and the strap, then wash your brush and use the wet brush to pull out a little highlight as shown.

12 Paint his arms with the skin mix, adding moonglow wet in wet for shading, then use a mix of French ultramarine and opera pink to suggest the shadow on his back. Allow the colour to bleed a little into his arm and the bag's strap.

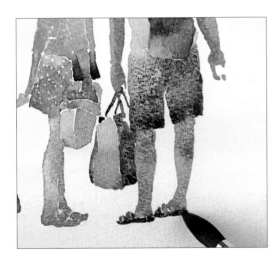
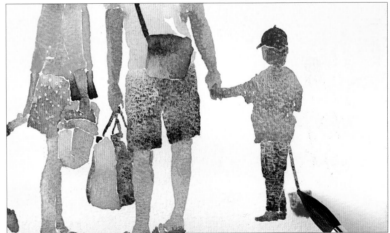

13 Paint his shorts and the detail of the bag with lunar blue. While the bag is still wet, add quinacridone coral to the panel areas. Finish the bag with quinacridone gold on the side facing us and paint his legs with the skin mix. Touch in his sandals with moonglow while the paint is still wet.

14 With a mix of opera pink and moonglow, paint in the older boy's hat; then use the skin mix and moonglow to paint his head; and then paint the top of his shirt using French ultramarine. Add cobalt teal towards the bottom of his shirt, then use moonglow to paint his shorts and spade handle, opera pink for the spade's head, and iridescent copper for the shoes.

15 Once the painting has dried completely, place a sheet of spare paper over the image to protect the figures. Use the large round brush to wash over the beach area with lunar blue (see inset) then load the old flat brush with a mix of iridescent copper, quinacridone sienna and quinacridone gold. Draw the burnishing tool over the bristles to flick the paint over the beach area while it is wet. Next, flick interference lilac over the beach in the same way.

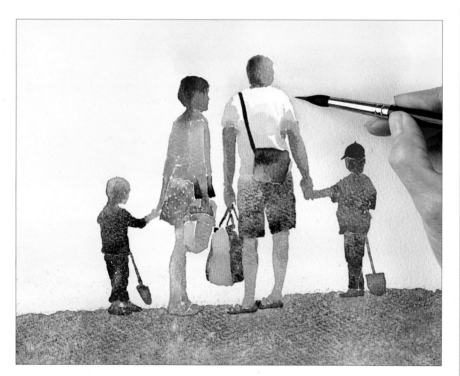

16 Use the large round brush to wet the area around the man's shoulders, then use the pointer to add touches of very dilute phthalocyanine blue (green shade) to add some definition. Carefully remove the masking fluid by rubbing it away lightly, then add a subtle touch of cobalt teal to the sandal straps. Once dry, remove the masking tape to finish.

The finished painting.

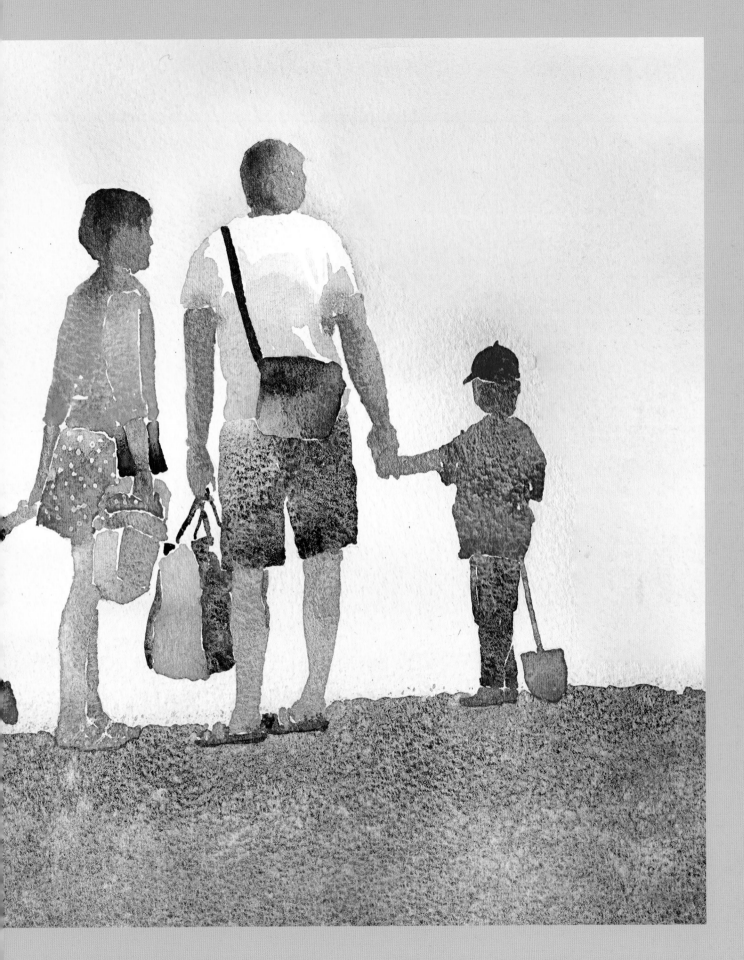

Moving forward

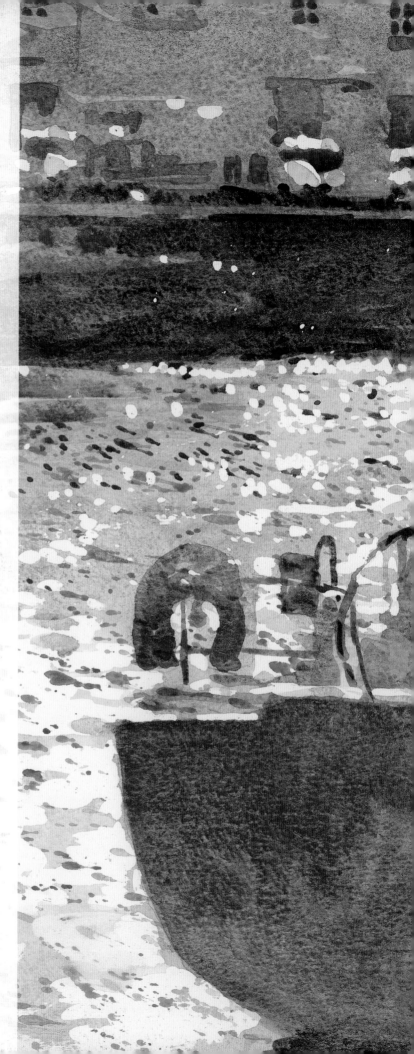

Now you have experimented with your water soluble materials and learnt the basics, you can move on to more ambitious and rewarding artworks, safe in the knowledge that you can react and adapt to any situation.

This section of the book explores creative composition, how to use colour, hue and tone effectively, and introduces new techniques like sgrafitto and tricks like using salt to allow you to produce particular effects in your artworks.

Beware of using tricks for the sake of effects. That said, tricks are great, and we should not be dissuaded from using them. After all, we can use a tiny brush to paint individual leaves on a tree or we can use a stippling brush for a similar effect; we can drop a grain of salt into a wet wash for a starburst, or we can try and lift out a section afterwards; we can apply masking fluid to avoid small white areas or we can painstakingly paint around them.

Ultimately, the choice is ours. Personally, I do not think it matters how we create effects as long as they are a means to an end, and not simply for the sake of adding effects.

Coming into Harbour
42 x 31cm (16½ x 12in) watercolour paint on Bockingford Not surface paper. After positioning masking fluid to retain the lightest tones, I laid a number of granulating washes and allowed the pigments to create the textures for me naturally. I used the beautiful paint lunar blue to achieve the darkest tones and yet retain a lovely vivid under colour. To adjust the tonal values of any areas that were too dark, I added interference lilac over the top. This had the additional benefit of adding a shimmering depth to the painting.

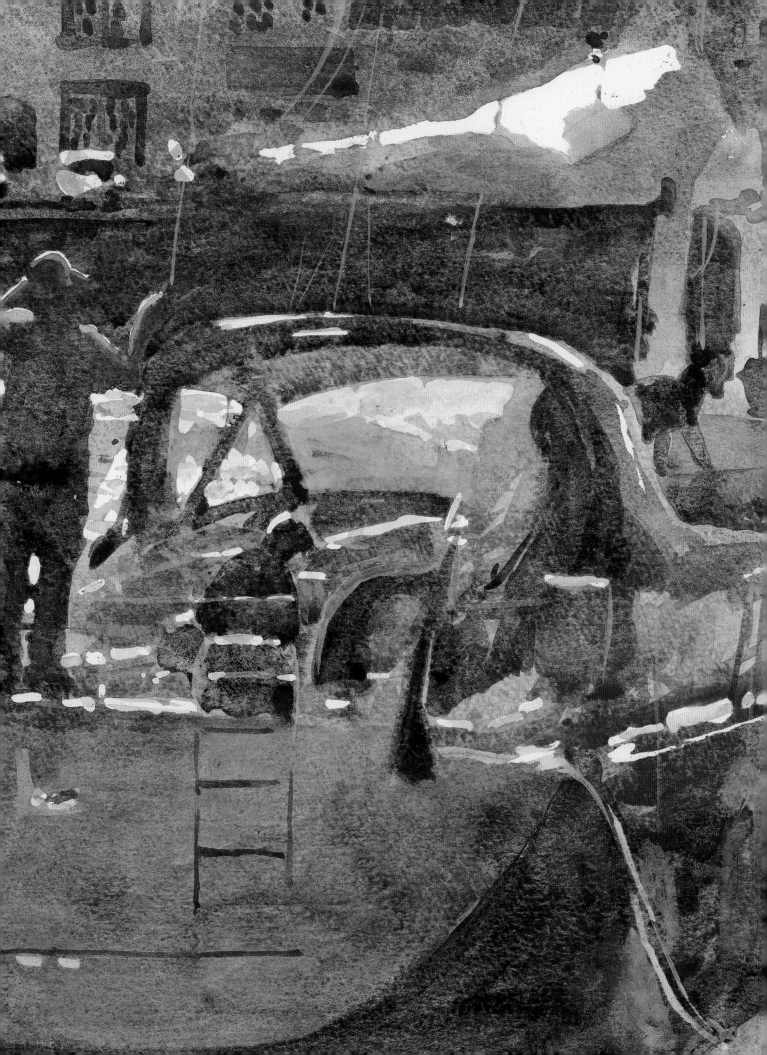

Be prepared

If I am about to begin a painting, the experimenting is all done. I never experiment on ideas or techniques on an actual painting – why risk it? I make sure I have done all my trials and ideas first on a different sheet of paper. Of course there are times that I need to react to a situation, but a reaction is never an experiment.

When you sit down to begin a more complex painting, ensure you are mentally and physically prepared. Confidence plays a huge part in any painting, and if you know what you are going to do, you am more likely to succeed. The keys to success as you move forward with your artistic journey are the three 'P's – Practice, Preparation and Paint.

Practice

If you were a musician you would never wake up on a Monday morning and play a new concerto. You might warm up with a few scales and play some small sections of the piece, then once you had tried adding sections together you would put sections together. Finally, you would attempt to play the whole piece.

Practice covers all of the drawing and painting techniques, compositional layouts and choice of media you will use, along with colour mixing and choice. All of these are practised first to ensure you are ready to tackle the work.

Preparation

Once you have practised and are ready to begin, make sure you have everything you are going to need close to hand for that particular project. This includes all the art materials as well as easy access to any ideas or reference work you need.

Paint

Relax – this is the most rewarding part. You have a firm idea of you want to do, you have tried out any tricky bits, you have allocated yourself this time and now you can enjoy the benefits of your practise and preparation and can simply enjoy the painting process.

Opposite
Calm Morning in Polperro Harbour
32 x 45cm (12½ x 17¾in) mixed media on 540gsm (200lb) board. This painting demonstrates how the three 'P's work. I carefully chose and cut out small sections of colour and texture from magazines, along with small sections of text. I chose different sizes, typefaces and colours, but all had a coastal theme.

I first placed all the collage pieces on to my painting and began moving them around. After careful thought, I selected and placed various colours and textures and then photographed the painting. This was absolutely vital, as it would be almost impossible to remember the position of my collage once I had moved it all to begin painting. I blocked in all the base colours using dilute colours, then secured the collage pieces in position. The more opaque and deeper colours were then added and transparent colours were washed over the collage pieces. Artbars were used on their sides to create added texture and the whole painting was slowly built up.

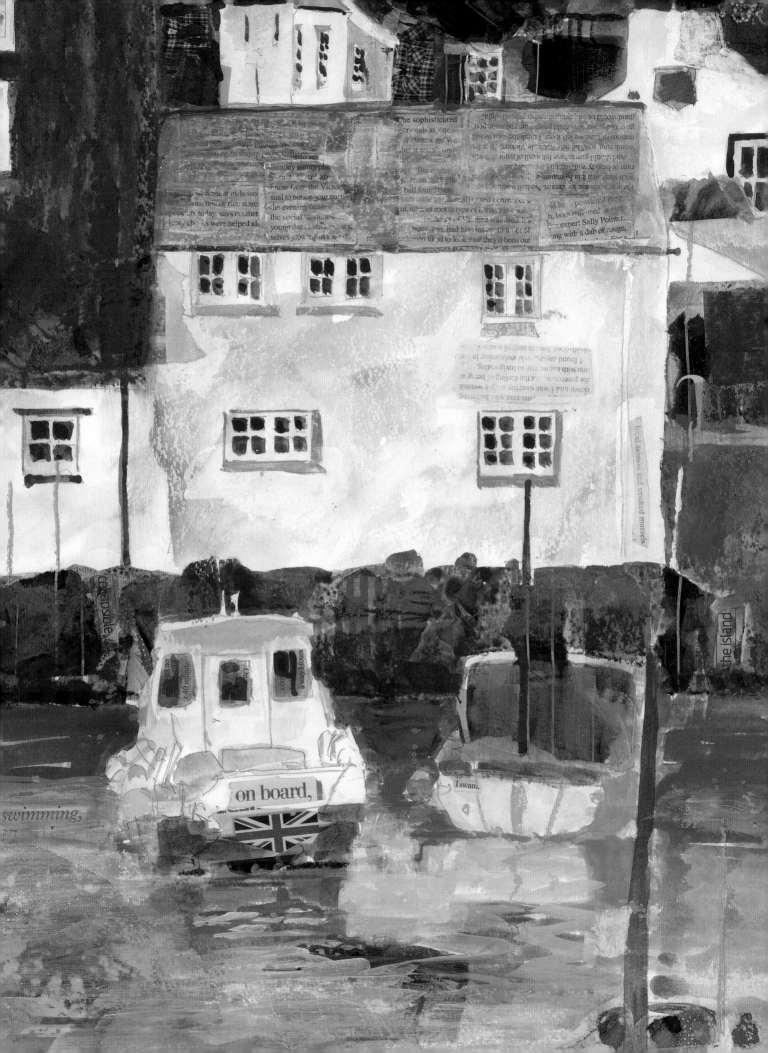

Tone

Tone can also be known as value. It is simply the relative lightness or darkness of a colour. Tonal value should not be confused with colour.

Understanding tone is essential for interpreting light. Every object is defined by the light falling on it, so looking at the direction of light and how it falls across the different surfaces is vital to create form.

Light and tone

The sheep painting below uses just five blues, each with a different tonal value which allowed me to create the form of the sheep. If all of the blues were the same value, the sheep would have no depth and would appear flat, or merely a series of shapes.

The light falling on the sheep is coming from the right. The left side of the sheep is lit by reflected light and therefore not as light in tone as the light on the right.

Five inktense blocks were chosen for their varying tones. Colour was applied directly on to the paper, ensuring that the darkest colours were placed boldly in the darkest areas and the mid-toned blues were placed in the mid-toned areas. The lightest tone is left as white paper, and I was careful to ensure no water touched the lightest sections when it was added. This ensures a strong tonal contrast is maintained.

These three colours are all different in hue, but their tonal values are the same.

These colours are the same, but their tonal values are different.

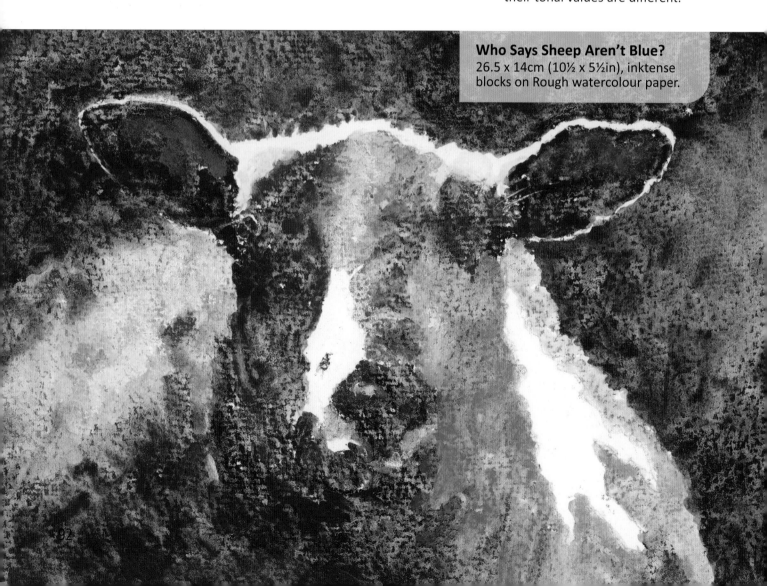

Who Says Sheep Aren't Blue?
26.5 x 14cm (10½ x 5½in), inktense blocks on Rough watercolour paper.

Understanding contrast

Contrast is very important in any painting. Strong contrasts can be achieved by varying tones as well as varying colour. If we had two colours – a yellow and a lilac, for example – they could be the same tonal value but would contrast strongly in hue.

However, you can create strong contrasts using just one colour – see the lower swatches on the opposite page for an example. Here, the same colour is shown at different levels of dilution, which changes the tone. The painting below uses a very subtle mix of colours but still contains strong contrasts.

Contre-jour

Contre-jour is usually translated as 'against the light'. More literally translated, it means 'against the day'. Any artist who enjoys painting light will at some point explore this contrast of light at its most extreme. Much of the subject will appear in silhouette or partial silhouette when the bright light seems to almost shimmer at the edges of the subjects creating lost and found edges.

It can be so bright, that sometimes it is difficult to see the subject for more than a few seconds at a time. *Coming into Harbour* (on pages 88–89) is a good example of this, where a lot of the detail is lost and the tonal values are extreme, so much of the detail is implied rather than painted.

Evening Walk
31 x 25cm (12 x 9¾in) artbars on canvas board. A limited number of subtle colours were used to emphasise the large expanse of water and beach, while in comparison, the subject matter is tiny. The surface of the canvas board creates the texture suggesting a shimmering scene.

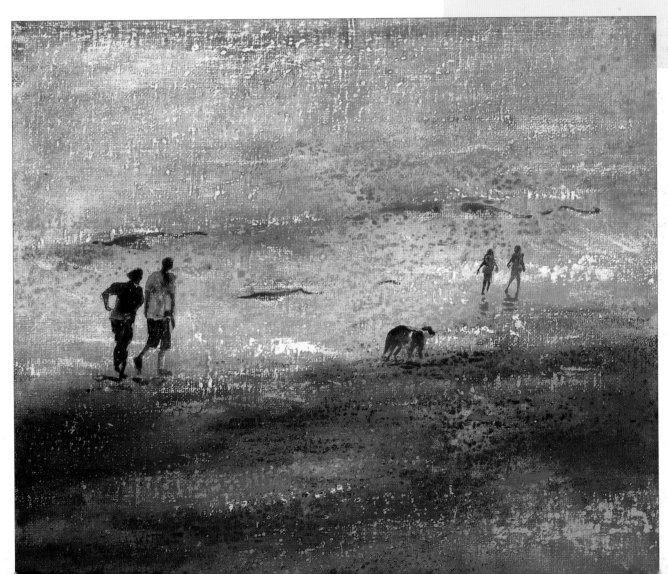

Changing the way your work looks

The simplest of subjects can be transformed into something quite fascinating by altering the appearance of the surface or by implying textural interest. That said, avoid going mad using every trick in the book (if you will pardon the pun) to create your textures.

Using the wet surface

Changing the way the paint looks while it is wet involves forward planning. It is no good wishing you had added salt or soap bubbles once the paint has dried, so experimentation and forward planning are vital.

Using salt

Salt can create beautiful effects when even a single grain is dropped into a wet wash – be it watercolour, ink or pencils. Dark colours work best, and caution is advised when dropping salt into the wet colour – avoid sprinkling randomly, but drop the grains with care.

Using plastic food wrap

Plastic food wrap can be placed on top of a wet wash, manipulated into shapes and allowed to dry. This creates a lovely angular texture of drying lines as the paint dries under the plastic.

Using soap suds

Using soap suds can create fabulous tiny circles as the paint dries. The soap bubbles are prepared by pouring a small amount of cold water into a bowl and adding liquid soap, then the mixture is roughly swished about to create a lather or foam of bubbles in whatever size you prefer.

 The watercolour or liquid wash is then placed on to the paper and the bubbles are scooped up and gently placed on the wet surface and left to dry. This needs a fair bit of patience as it can take a couple of hours to dry.

Lifting off

This technique, sometimes known as stonking, can be used across all media and involves placing kitchen roll or absorbent paper on top of a wet or damp surface. The absorbent paper is then lifted away, taking some of the pigment with it and leaving a texture.

 As a general guide, the wetter the paint, the less texture is created. The drier and thicker the paint, the more texture is created.

Overlaying colour

Opaque colour can be placed over a previous colour if dry. This allows bright or light colours to be placed over dark ones. This technique is sometimes also known as glazing.

 If you are using artbars or sticks on their side, they can be dragged over a wet colour to leave a second colour on the surface of the paper. This works best on Rough or Not surface papers.

 If using watercolour, inktense or inks, this technique works best when the first layer of paint is dry and the second layer is painted on top of it, revealing the colour underneath as if a layer of tissue paper has been placed on top of it.

Salt
Watercolour was painted on to smooth paper before salt was dropped carefully into the wet wash. It was allowed to dry naturally on a flat surface.

A Perfect Match

26 x 21.5cm (10¼ x 8½in), inktense pencils and artbars on Not surface cotton rag watercolour paper. Bright green artbar was dragged over bright pink inktense pencil on the side of the bag, while the bright pink front of the bag was toned down by lifting colour off. The dark red spots were created by coating bubble wrap with inktense and pressing this against the surface. The sides of the artbars were used to create texture all over the picture whilst the spots were painted on the shoes using an opaque colour.

Boats on the Slipway

33 x 19cm (13 x 7¾in), watercolour paint on Not surface paper. Plastic food wrap was used on the background to help suggest movement in the water. Masking fluid was used on the lobster pot to preserve the white paper for a turquoise glaze at the end of the painting. Soap, used in the foreground of the painting, suggests pebbles.

Below the surface

When we look at any finished painting we are not necessarily aware of what is underneath the surface. Paintings can be built up using layers which add luminosity, depth and intrigue. Revealing even tiny glimpses of what is underneath can be quite enticing and can add another dimension to a piece.

Moving surface layers

Sgrafitto

This is the technique of scoring, moving or cutting into a top layer of colour to reveal what lies beneath.

This can be done using a palette knife, a rounded tool like a perspex brush handle, the corner of a plastic card or even a fingernail whilst the painting is still wet. This moves the top layer of paint. When dry, pigment can be scraped away using an embossing tool, craft knife or similar.

Lifting off

Also known as stonking, lifting heavy or wet pigment can be done using kitchen paper, blotting paper, even newspaper as described on page 94. All will result in a slightly different effect depending on the thickness and wetness of the paint surface, and what lies beneath.

Absorbent paper can be gently laid on a small section (or indeed large areas) of the painting and gently pressed to lift just a little pigment or firmly pressed to lift more. Patterns and textures can be suggested depending on the material pressed against the surface.

Tumbler with Flowers
9 x 23cm (3½ x 9in), inktense artbars and acrylic on Not surface paper. Various colours were dropped on to wet paper. While wet, the white daisy petals were revealed by using a brush handle to move the wet paint.

Once the background was dry, stalks were added using acrylic on the edge of a piece of card and tapped on to the paper. Once the painting had dried, the tumbler shape was painted in using dark inktense and the lines were immediately moved in a top-to-bottom direction using the brush handle.

Notice how the moved wet pigment pools at the bottom of the stroke. This always happens, so the direction the pigment is moved in can sometimes be important.

Revealing layers

The painting on this page has so many layers that it is hard to imagine that it began with a gouache base of sunflowers, leaves and background. I wanted to create something that diffused mysteriously into its surroundings – not to suggest mist, but simply to pose an interesting challenge for the eyes.

Over the base layer, I introduced the turquoise artbar colour and painted as well as flicked, scraped and stamped it on to the surface, making sure I covered the defined outer areas of the subject. It can be quite daunting to 'lose' something previously painted, but also exciting as a different effect is created.

I next rubbed a deep indigo (tertiary purple) artbar over the wet surface of a sponge and dabbed the sponge on to the surface to suggest the edge of the pot. To link this dark area with the centre of the flower, I added droplet shapes in the centre using a stencil. The edge of the pot was suggested using a piece of card as a mask.

A strong inktense blue wash was then painted over the whole pot and immediately scraped away using a brush handle to reveal the previous colours underneath.

Using the droplet shape stencil as my theme, I diffused the whole foreground area using a vibrant blue acrylic.

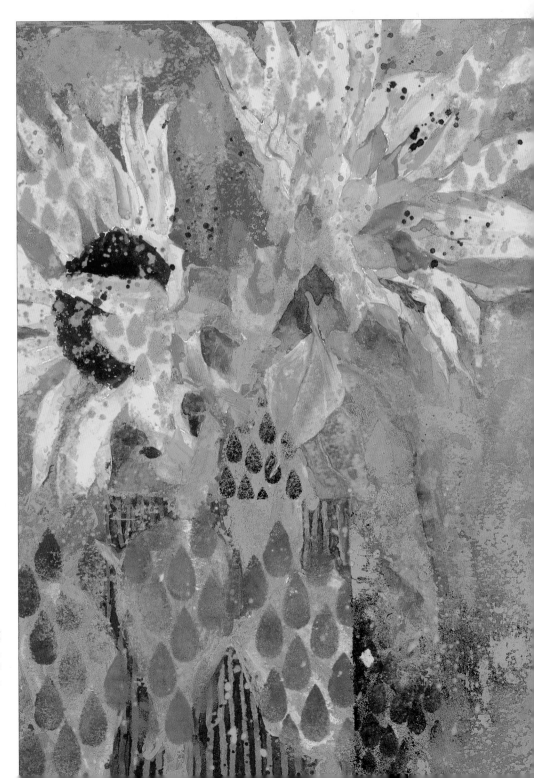

Sunflowers in a Striped Jug
26 x 35.5cm (10¼ x 14in), mixed media on Not surface watercolour paper.

Smoke and mirrors

Usually when we paint we are attempting to cheat the eye into believing that something which is two-dimensional is actually three-dimensional. It is our task to deceive the viewer without them realising it. This can be achieved in various ways, some of which I explore here.

Suggesting that something has a curved surface usually requires different tones. However, shape alone can suggest form. If you look at *Patterned Jug* (below), you will see that the pattern is completely flat with speckled texture and blocks of colour; but the curved shape of the jug is enough to deceive the eye and suggest the curve. The inside of the jug is depicted using pure white with no tonal variation at all, and yet we see a three-dimensional jug.

Directional light can also help to suggest form. In *Cool Kid* (see opposite), the bright white paper suggests strong sunlight and creates most of the three-dimensional illusion. The boy's collar is solid black and his green top uses the same colour overall with the addition of a cool blue to suggest the shadows – there are no subtle tonal changes and yet he has definite form. The lovely textures created by the media used also add depth and interest, all contributing to the illusion.

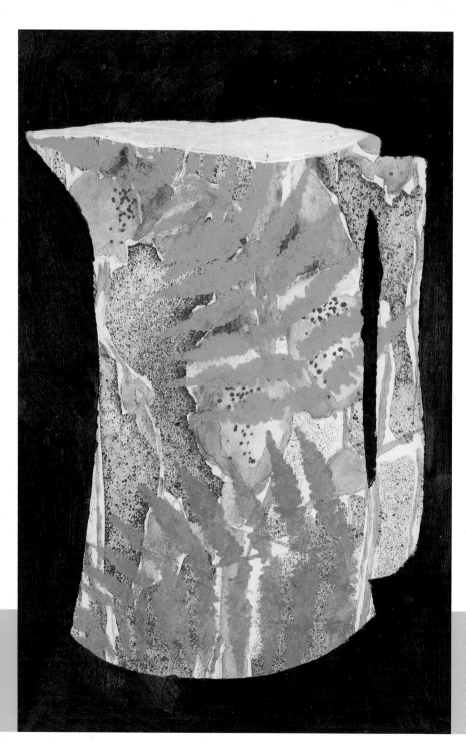

Patterned Jug
13 x 20cm (5 x 7¾in), inktense blocks, inktense pencils and acrylic paint on smooth HP watercolour paper.

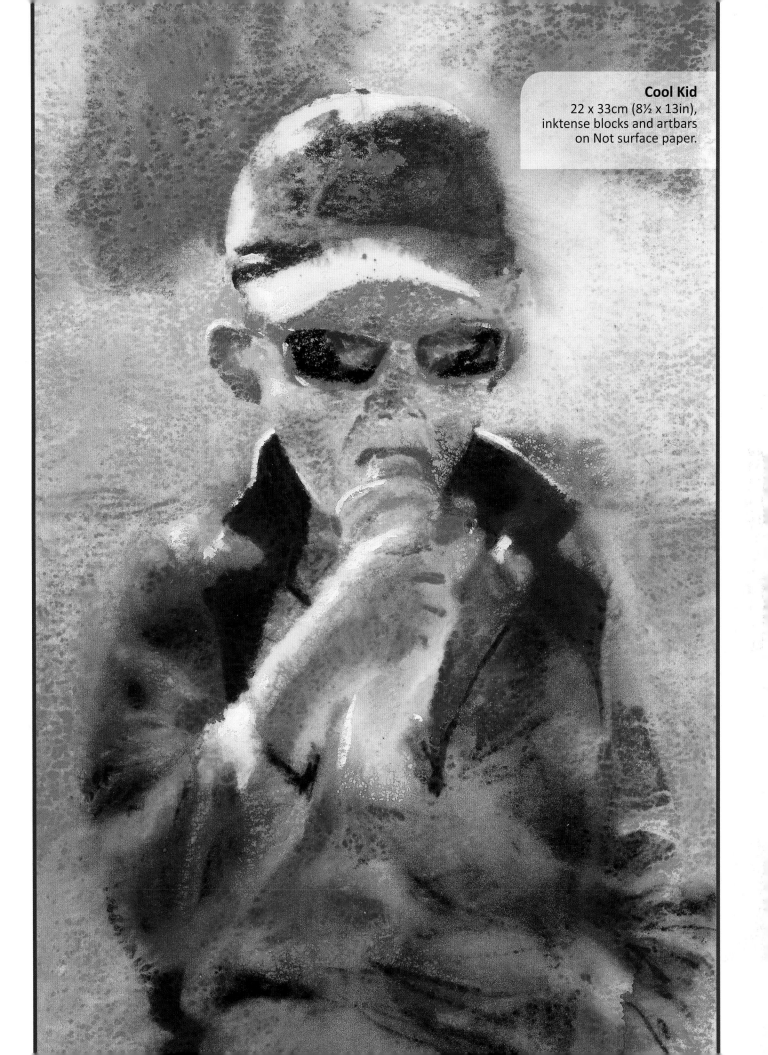

Cool Kid
22 x 33cm (8½ x 13in),
inktense blocks and artbars
on Not surface paper.

Creative composition

Avoid playing safe and choosing the usual viewpoint. Instead, aim to be more creative and look for alternatives. When I was at art college we had an evening life drawing class, and as I usually arrived after the majority of the group they had all chosen their positions in front of the model. I was usually left to find a suitable place around the edge. My compositions always seemed to be more interesting. Instead of the usual elongated model across the entire width of the paper, I would end up with a view of the back of the head and shoulders with little feet in a corner or huge feet and a tiny head in the distance.

I began to realise that my pictures had the advantage of being more interesting to the viewer, so instead of rushing to get a place at the front, I waited and was happy to find a more interesting view. This has led me to look for the unusual rather than the obvious.

Cropping for impact

When I taught weekly watercolour classes I noticed that many people had difficulty with composition. If they used a photograph, everything in it went into their painting. If I set up a still life, everything was included, as well as lots of superfluous space around the actual subject. This sometimes led to rather dull pictures.

A rather ordinary painting can be transformed into something quite dramatic by cropping some elements or excess space out of the piece.

A very simple way to show how cropping can cause more impact is to cut out two L-shaped pieces of mountboard or white card and place these over sections of a painting, covering any unnecessary spaces. The result can be astonishing and never ceased to amaze my students, who saw instantly how to improve their artwork.

On a much smaller scale, it is the same as standing up close to a large painting: if something fills your area of vision, it has more impact than if it is placed at a distance with space all around it.

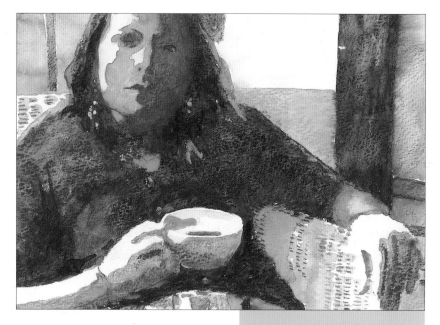

Emma Listening
28 x 20cm (11 x 8in), watercolour paint, inktense and graphitint pencils on Not surface paper. This is a good example of an unusual crop. The teacup is the focal point, and parts of the figure leave the edge of the work.

Using spaces

Spaces are an important way of creating areas of calm within a painting. If there is texture, colour and detail all over the painting, the impact can be lost. Including spaces of light or calm can prove very effective in ensuring the eye is drawn to the correct areas.

Notice the spaces left in *Emma Listening*. The unpainted gaps imply light, but the background block in reality was a complex view outside. Imagine how distracting it would have been to include what I actually saw. Using this space focuses our attention on the figure, not the outside.

Reserving paper

There are various ways of reserving paper other than avoiding it, especially if we want more complex sections of light.

• Low-tack masking tape can be stuck on to paper and gently peeled off to reveal clean paper. This works best for geometric shapes and blocks, although shapes can be cut out of it.

• Masking fluid can be painted on to the paper using a brush or applied with tools of various sorts, but it can also be poured or drizzled on to paper. Avoiding thin or small areas within a painting can be tricky and masking can prove to be a good solution.

• Wax can also be used to protect the paper and a simple wax candle works well. However, although wax resists water, it can be greasy if pencils or blocks are used over it. The results are better when using a brush and wet pigment. It should also be remembered that wax can not be removed, so accuracy is vital when using this method of reserving paper or colour.

Watercolours were dropped and splashed on to an area masked with a swirl of masking fluid. Notice how pigment gathers around masked sections – which protects the paper and acts as a barrier. Once the masking is removed a crisp clean white line is revealed, as if by magic.

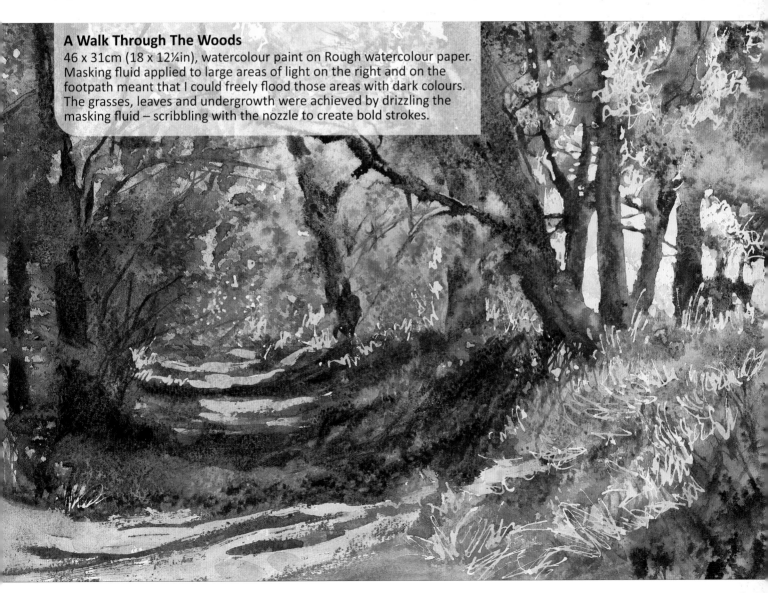

A Walk Through The Woods
46 x 31cm (18 x 12¼in), watercolour paint on Rough watercolour paper.
Masking fluid applied to large areas of light on the right and on the footpath meant that I could freely flood those areas with dark colours. The grasses, leaves and undergrowth were achieved by drizzling the masking fluid – scribbling with the nozzle to create bold strokes.

Negative shapes

Some shapes we naturally see as positive because they are recognisable. When we draw or paint, we tend to make figures or objects that are definite positive shapes. The negative space in a composition is any part which is not the actual subject. It is the space surrounding or in between a subject. This space has just as much importance as the subject because it too has a shape and each shape within a picture affects its composition and balance.

Positive and negative spaces can be fascinating and interpreting them is not necessarily clear or simple. Look at the circles on the skirt against the white background (see *Light Figure*, opposite), then look at the same circles on the dark background above the shoulder of *Dark Figure*, below. Both sets of circles are the same size and both appear to be positive shapes rather than circular negative 'holes' – yet one is on a dark background and the other on a light one. Next, look at the mesh pattern on the head in *Light Figure*. Why do we see the hexagon shapes as positive and the mesh between them as the negative space, even though the light mesh is part of the positive shape of the figure? It even stops at the outer shape of the head and does not exceed this.

The reason is simply that the hexagon is a shape we all recognise and contrasts strongly against the white ground. If the hexagons were white and the narrow spaces dark, the hexagons would merge into the shape of the head and the dark mesh would be more noticeable.

Dark Figure
42 x 29cm (16½ x 11½in),
inktense blocks and artbars on
smooth watercolour paper.

Light and dark

The negative shapes in *Dark Figure* (see opposite) are the space between the arm and the hip as well as the background. This entire area is covered with patterns, shapes, colours and textures, but we are left in no doubt that the figure is a positive shape. This shows how negative spaces are not always dark, they can equally be light. Indeed, it is the light negative shapes we so often fail to see as we are naturally drawn to see the positive darker shapes.

In *Light Figure*, below, exactly the same silhouette shape is used as in *Dark Figure*, but the light and dark areas are reversed. The negative space remains the same although the subject is tackled differently. Here the subject emerges from the pattern, the positive shape being suggested rather than stated.

Light Figure
42 x 29cm (16½ x 11½in), inktense blocks and artbars on smooth watercolour paper.

Blue Ewe

This demonstration shows why we need to keep all of those trials and experiments: they have the information we need to select colours and techniques and help us plan our painting to achieve success.

Once we become familiar with our various materials we can then mix and match them to create the effects we want when we want them. All this takes time and practice, so keep all of those trials and experiments – do not throw them away!

The important thing is to make notes on your experiments – how certain effects were created, which colours, techniques or tools were used, for example. This is almost as important as keeping them in the first place. Following the instructions here will help you to produce your own vibrant painting and kick-start your creativity.

YOU WILL NEED

Inktense blocks: shiraz (0600), red violet (0610), mauve (0740), dark purple (0750), dusky purple (0730)

Artbars: pale cobalt (A28), duck egg blue (A31), opaque white (A71), blush (A23), violet earth (A42), iris (A10), process magenta (A08), dark indigo (A59)

Watercolour pencils: burnt yellow ochre (60), French grey (70)

Not surface watercolour paper, 300gsm (140lb), 28 x 38cm (11 x 15in)

Masking tape and board

Spray bottle

Kitchen paper

Before embarking on a painting I often use the colours I intend to use to trial ideas, as shown in the example above. I can then use the ones I like and reject the ones I do not. I never experiment on my painting.

1 Make a border around the paper using masking tape, then draw out the basic shapes of the sheep using burnt yellow ochre and French grey watercolour pencils. Use the shiraz and red violet inktense blocks to add darks over the chest of the sheep, extending down to the bottom of the page.

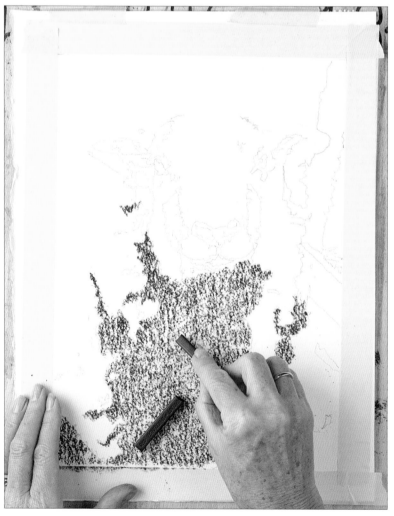

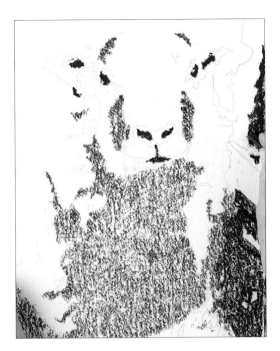

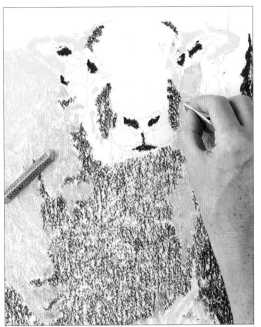

2 Use the mauve inktense block to add darks across the sheep's face, including the nostrils and mouth. Switch to the dark purple inktense block for the eyes, recesses of the ears and the background on the right-hand side.

3 Use the pale cobalt and duck egg blue artbars to add the light on the fleece. The colours used here have similar tonal values. This adds variety and interest without complicating the texture too much. Feel free to experiment with other similarly-toned light colours for a different effect.

4 Put down a layer of opaque white artbar over the muzzle of the sheep, then overlay blush artbar over it. Add some touches of blush artbar elsewhere, to help link the picture together.

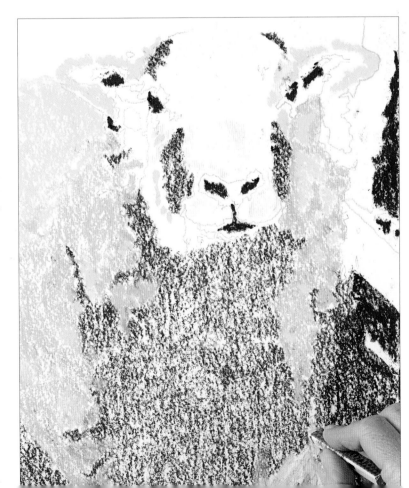

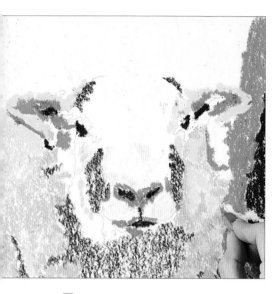 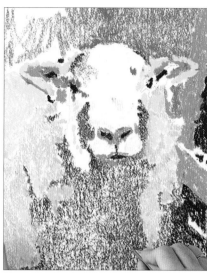 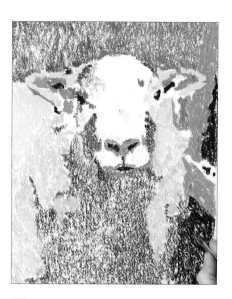

5 Use violet earth artbar to add colour to the right-hand side of the background as shown and to add contrasts near the ears, nose and mouth.

6 Use the red violet inktense block to extend the shadow on the fleece up to the muzzle, then switch to the iris artbar to add the background and a few touches here and there. Keep the work fairly loose, with gaps on the top right-hand side, but work more heavily near the top of the sheep's head.

7 Fill in the gaps in the background on the top right-hand side using process magenta artbar. Add a few flecks of the same colour for interest across the picture.

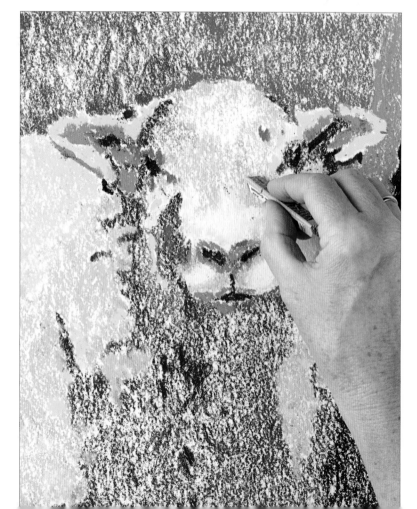

8 Use dark indigo artbar to add variation in the darks around the edges of the head and on the sheep's chest, then add variation to the light areas by overlaying with more pale cobalt artbar.

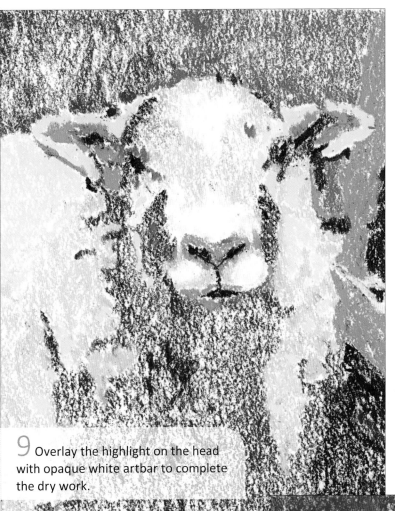

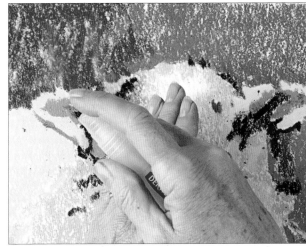

10 Using your hand to protect the sheep's face, use the spray bottle to wet the background with clean water until it pools slightly.

9 Overlay the highlight on the head with opaque white artbar to complete the dry work.

11 Spray the rest of the picture fairly well, but not as heavily as the background. Use the least water on the sheep's head and face.

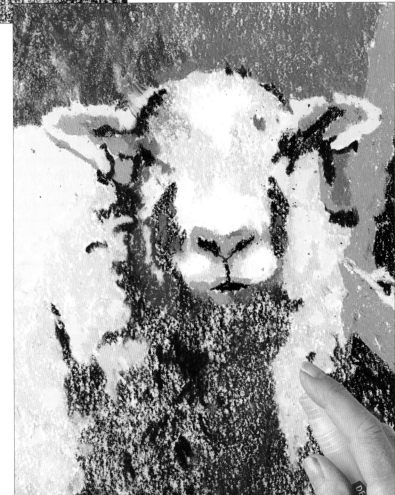

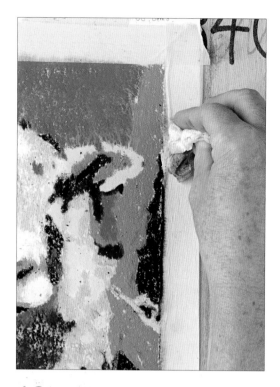

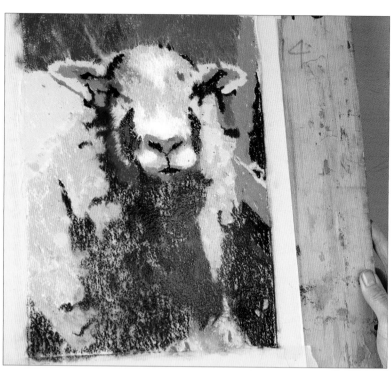

12 To prevent wet colour from running back in as the water dries, use kitchen paper to soak up any excess that runs over the masking tape border.

13 Pick up the board and tilt it slightly to encourage the colour to move about while it is wet.

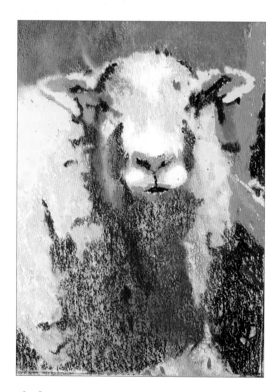

14 Lay the board down flat and allow the colour to dry completely before continuing.

15 Create a glossy highlight by adding a dot to each of the eyes using opaque white artbar.

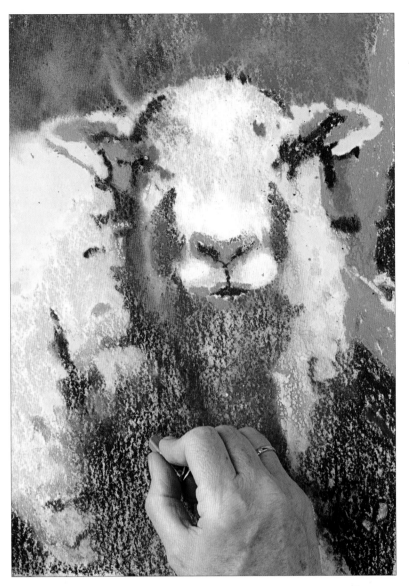

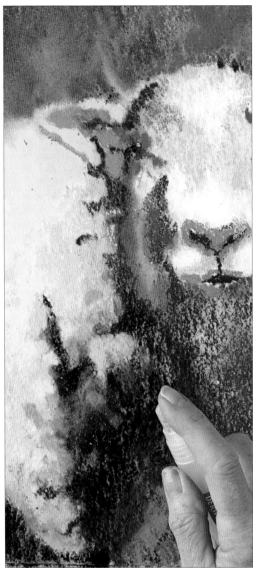

16 Develop the texture on the lower-left hand side of the fleece using dusky purple inktense block and pale cobalt and violet earth artbar.

17 Work upwards on the left-hand side using duck egg blue and pale cobalt artbars, then spritz the entire left-hand side.

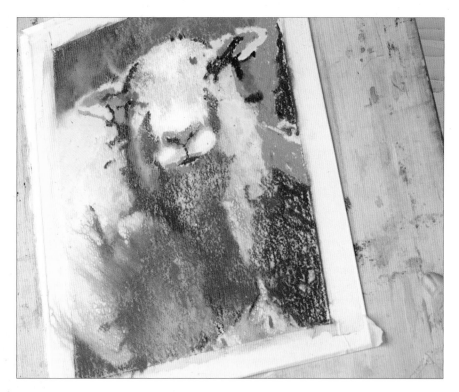

18 Allow the water to begin to move and spread the colours, then pick up and tilt the board to encourage the colours to move.

19 Allow the painting to dry completely. It is important that you lay the board completely flat, as this is the period where the subtle effects of the artbars will develop, and this is reliant on the water not moving.

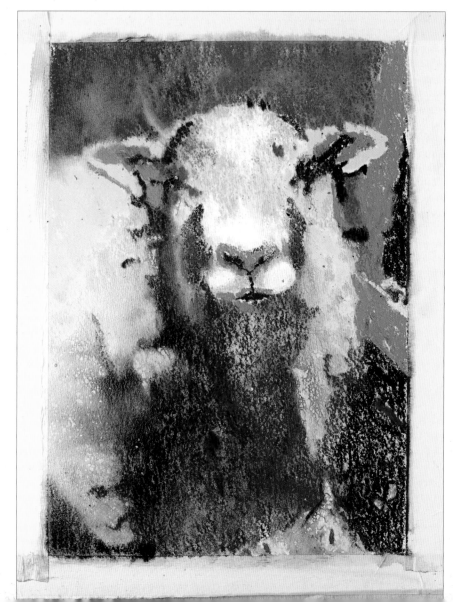

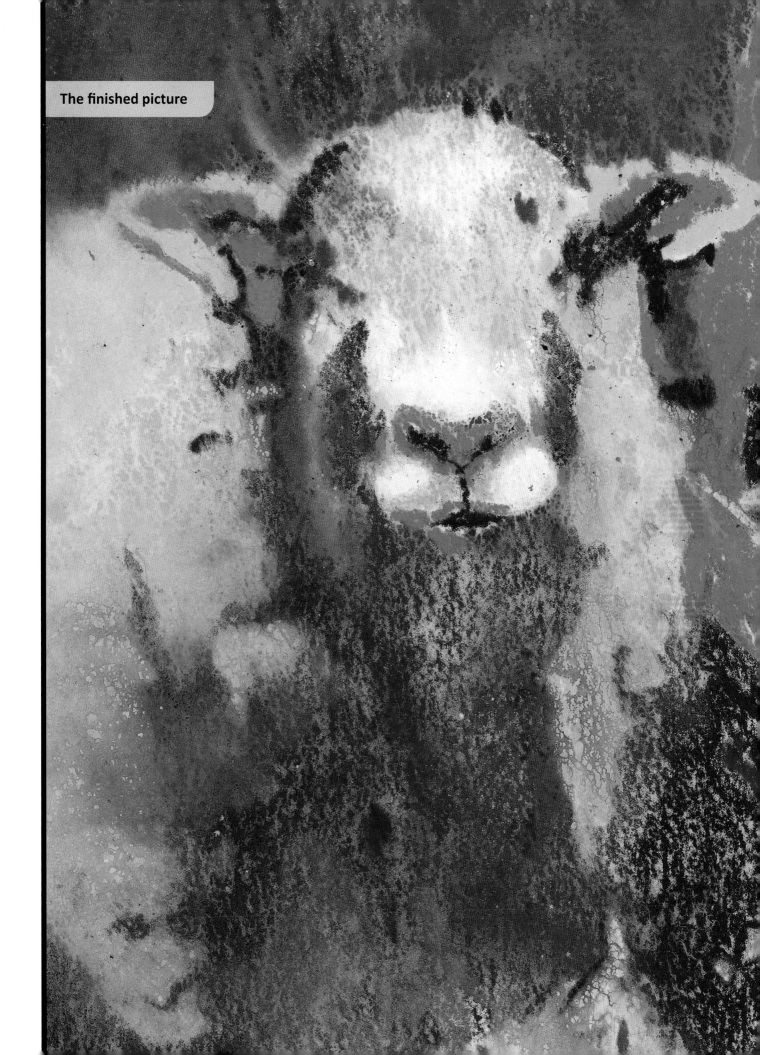

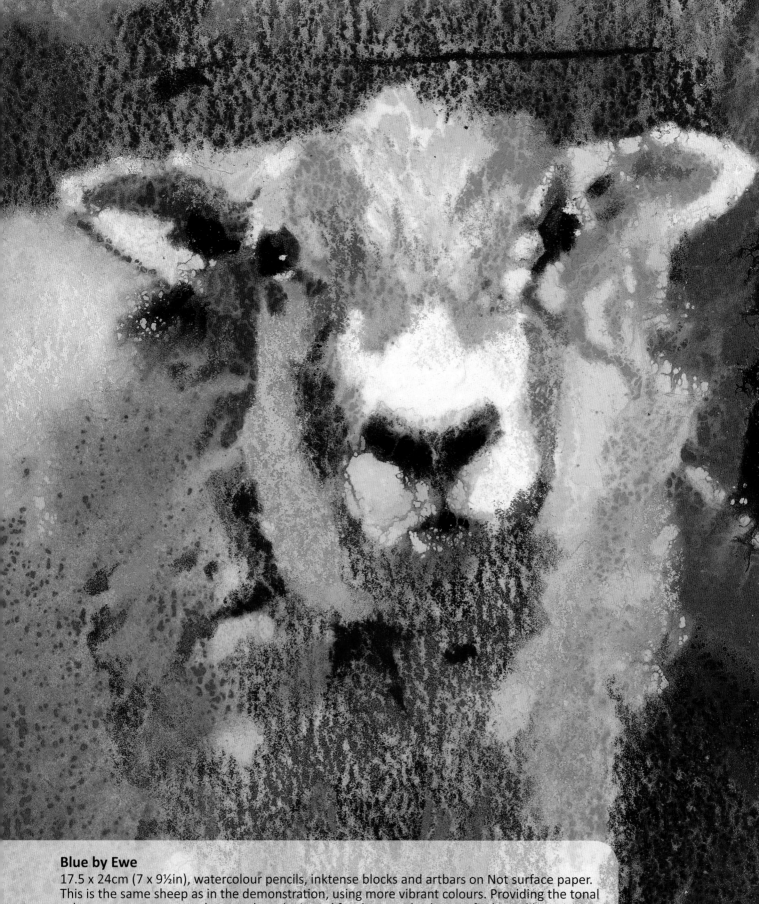

Blue by Ewe
17.5 x 24cm (7 x 9½in), watercolour pencils, inktense blocks and artbars on Not surface paper.
This is the same sheep as in the demonstration, using more vibrant colours. Providing the tonal values are correct, any colour can be substituted for the actual colour – I find it so liberating using any colour I choose rather than matching a particular colour. Try your own interpretation using any colours you like, but remember to retain the tonal values.

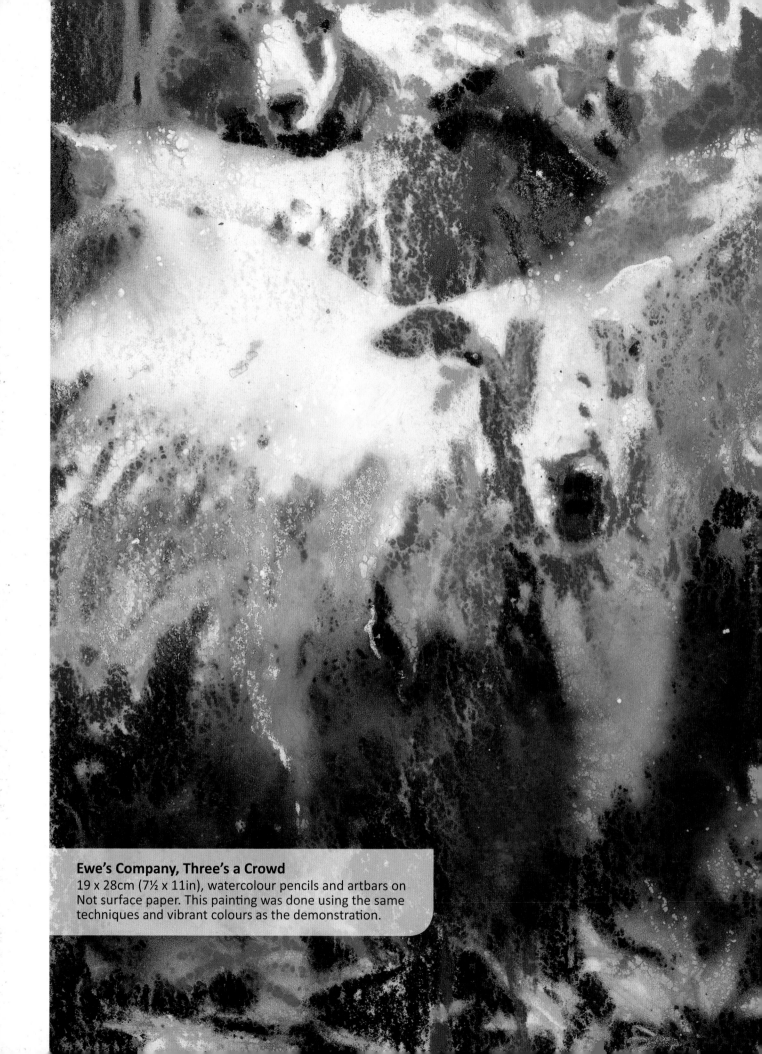

Ewe's Company, Three's a Crowd
19 x 28cm (7½ x 11in), watercolour pencils and artbars on
Not surface paper. This painting was done using the same
techniques and vibrant colours as the demonstration.

Your own style

We all want to find our own style – our own way of describing our subjects, something that makes us stand out as different or unique. It can take a long time until you eventually decide on how you want to paint, and some people never decide; they keep on searching.

Explore lots of subjects and try different media. One important thing to remember is that your style need never be fixed, it can evolve with time.

Finding inspiration

The work of artists you admire may not necessarily be how you want to paint yourself. Collect images of paintings that inspire you and make a scrapbook. Spend some time deciding on what it is about each painting that you like – what attracted you to it?

You might make notes of what artistic styles or movements you particularly like, such as Impressionist, abstract, decorative, graphic or naïve. Copy techniques and paintings you enjoy in order to learn from them (as long as you do not exhibit these works as your own) and use them as a learning path.

Find your own level where you are comfortable and be yourself – do not try to be someone else. Choose subjects you want to paint. If you are painting a place, paint a place where you want to be. If you like cakes, paint them, then eat them!

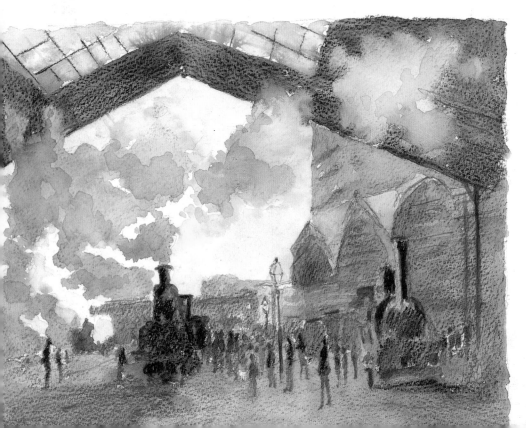

The Gare St-Lazare
26 x 20cm (10¼ x 7¾in), watercolour pencils on Not surface paper. This painting was inspired by Claude Monet's original. I used the pencils dry on dry to establish the colours then used the large round brush to thoroughly wet the surface. Once sections had dried the brushstrokes were added wet on dry. I used a paper palette to drop in colours wet in wet.

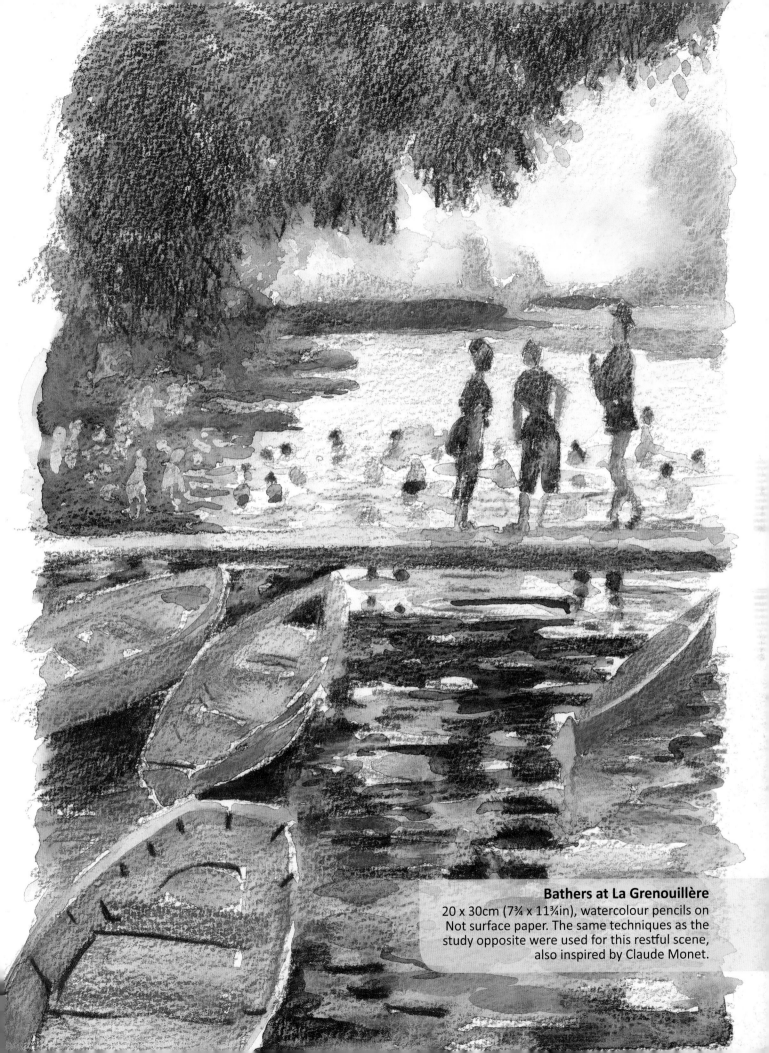

Bathers at La Grenouillère
20 x 30cm (7¾ x 11¾in), watercolour pencils on
Not surface paper. The same techniques as the
study opposite were used for this restful scene,
also inspired by Claude Monet.

Challenge yourself

Ask yourself what types of subjects, media and situations you avoid, then try to identify why they worry you. If you always paint within your own area of comfort you are unlikely to progress, so tackling these will most likely benefit you the most! Challenging yourself will bring success ever closer by improving your techniques and skills over time.

Developing a series of pictures

It can be both challenging and exciting to develop a series of paintings on a common theme. Over the next few pages I show a series based around the theme of a ballet school. These all stemmed from noticing a group of girls walking down a sunny street, obviously from a nearby dance class. I paid little attention to their features – I was struck by their similar black dresses and leggings, and it was how their skin contrasted so beautifully, creating almost abstract shapes that inspired me.

Ballet School (right) was my first painting and remains my favourite painting in the series. I love the almost abstract shapes created by the three dancers. My focus was the repeated pattern formed by their arms, so the heads and legs could be cropped: all I needed was enough information on the page to suggest three figures (see cropping for impact on page 100).

I chose to use inktense blocks and artbars on a Not surface paper in order to create texture, as the shapes and subtle tonal changes were to be very simple. I also needed to retain the clean shapes, so running colours would need to be controlled to avoid the risk of my shapes disappearing and losing their impact. The choice of colours needed to be limited and the tonal contrasts powerful, so I used black – a rare choice for me – and also a dark blue inktense for the foreground dress shape, as I thought too much black might be overpowering.

As artbars are opaque it is possible to adjust even the darkest of colours and work over them again. For example, once the colours were wet, I thought too much of the burgundy had run into the background light panel, so once the painting had dried I blocked in some of the mauve artbar over this and gently sprayed it again. It is important to be able to look at work objectively, be prepared to alter it and develop ideas towards new pieces.

Ballet School
21.5 x 30.5cm (8½ x 12in), inktense blocks and artbars on Not surface paper.

Although I rarely use black, I quite enjoyed the results on the finished picture, especially where it had run into brighter or lighter colours. This led me to tackle a second picture which was well out of my comfort zone, with black being used to draw my outline and create impact. I added to the task by deciding to have the dancers coming towards me, so there would need to be just enough facial detail to tell a story, as well as using brighter colours and suggesting a busy background street scene full of activity. I now planned to do everything I had avoided in my first painting, which led to *Promenading* (see right), which shows a bolder approach.

The line drawing needed to be simple yet bold, and the colour would need to run only a little. Once the colour was blocked in, I introduced a touch of bright pink and a swathe of turquoise, because I like the colour and I wanted a large expanse of a bright colour. The painting was then wetted and left to dry. Nothing further was added or adjusted after this. Although I like the dark outlines of the finished piece, the result was more illustrative than *Ballet School*.

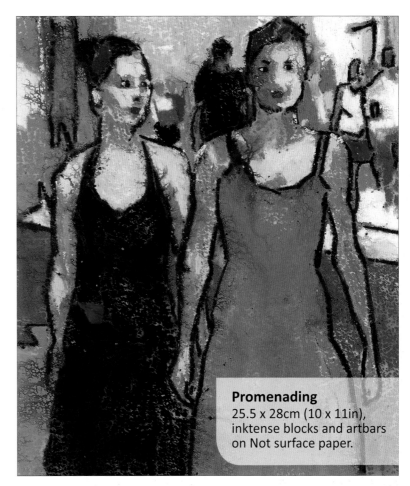

Promenading
25.5 x 28cm (10 x 11in), inktense blocks and artbars on Not surface paper.

I was not sure that this was the direction I wanted to move in, so for the next painting in the series, *Off to Lunch* (see left), I decided to use black for both dresses. This was adapted from the use of blue in *Ballet School*, but with additional touches of blue to emphasise the light reflecting off the black. I used no turquoise in this piece, instead brightening the skin colours for impact.

Wanting to concentrate on the shapes again rather than the linear structure, I used the same two figures but had them moving away from me so that all facial details could be avoided. This allowed me to concentrate on patterns and tone.

I sprayed the painting quite heavily with water and was pleased with the soft focus feel this gave the finished piece, which suggests movement.

Off to Lunch
20 x 23cm (7¾ x 9in), watercolour pencils and artbars on Not surface watercolour paper.

This led me to decide that the next painting should be worked in watercolour. Still concentrating on pattern and shapes I wanted to suggest a hot day, bright sunshine, and a busy street. Tone was my main priority for *On a Break* (see right), rather than getting bogged down in too much detail, so I splashed, flicked and dropped in colour using a large round brush.

I liked the freedom the watercolour paint allowed me but the sumptuous rich colours of my previous paintings seemed lacking, so for *Into the Sunshine* (see below) I used the same subject, cropped any superfluous background areas and approached it very differently.

My aims were the same as for *On a Break*, so a limited palette was essential. Learning from the previous paintings in this series I used some blue in with the black, complementary buttery yellows next to the mauves (see page 53 for more on complementary colours) and more intense skin colours, while allowing the colours to run more. I also decided to introduce a skin colour to the legs which I thought added more colour balance.

For *Always in the Shadow*, the final painting in the series shown opposite, I challenged myself to suggest facial details within an almost abstract setting. I cropped the composition to the heads and shoulders of the two figures and used watercolour pencils

On a Break
21.5 x 26.5cm (8½ x 10½in), watercolour paint on Not surface paper.

to block in strong tonal areas, then added inktense blocks and sprayed this with clean water. After adding more pigment wet in wet, I sprayed it again. Once dry, I added artbars to bring out textural details and alter the colours. For example, the dress on the left began life the same colour as that on the right, but I decided to change it.

I worked in many layers, allowing each to dry before continuing, and built up the painting over an entire day.

Painting a series of pictures helps us to develop techniques and realise what we find works and what does not.

Once you have finished your own series of pictures, place them against the wall, step back from them and choose which ones you prefer. Ask yourself why you like these in particular, and identify why you do not like the one you others so much.

Into the Sunshine
16.5 x 26.5cm (6½ x 10½in), watercolour pencils and artbars on Not surface paper.

Always in the Shadow
21.5 x 30cm (8½ x 11¾in), watercolour pencils,
inktense blocks and artbars on Not surface paper.

A step beyond

Once we understand what we can achieve using water soluble media, we can push the boundaries of our technical and creative ability.

Mixed media

Mixing the media we use can be a choice from the start or a development once a painting has begun. There are almost inevitably times when something does not work as we would hope, and covering sections with either paper collage or opaque paint can take a painting in another direction to achieve success.

Experimental sheets

On my experimental sheets I will try out which pens successfully draw over artbars, inktense or acrylics, as well as see how the different media adhere, resist or otherwise interact with each other. If I have a sheet of paper covered in different experimental techniques, I often overlay other media on top to see what effect this has. Sometimes splashing colours over a coloured base can be a perfect start for a mixed media picture rather than starting with a blank sheet of paper. The painting to the right, *I Came Across a Blackbird*, began like this. I wanted to see if my brand of gesso was opaque, so working on a sheet of Not surface watercolour paper which had colour swatches on it, I painted gesso over a stencil of a bird in a cage. Once dry, this left a raised shape on the paper.

I then wanted to see if colour would pool around these raised shapes leaving an edge, so I painted bright blue inktense randomly over the cage, leaving a raised shape. This worked so well I decided to use the experiment to form the ground for a painting at this point– but I could equally have discarded it or used it for something else.

Continuing the picture, I cut out a paper mask of a figure, placed it into position and secured it temporarily with adhesive putty before placing a leaf stencil on top and stippling bright green acrylic paint over the whole painting. Using one stencil on top of another helps to create depth and interest.

Building up the layers now required the paint to be thicker and opaque in order to cover previous layers, so I used acrylic paint, which works well for this.

I Came Across a Blackbird
15 x 25.5cm (6 x 10in), inktense blocks, fineliner pen and acrylic paints on Not surface paper.

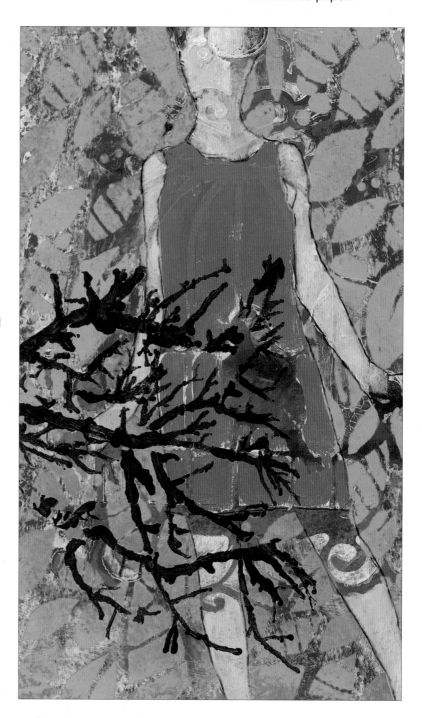

120

When the stencil and the paper mask were removed, I used pink acrylic to paint the dress, being careful to avoid the bird and small areas of the original cage stencil, which helped to bring emphasis to these areas. The dark tree shape was added as the next layer. Once dry, it became obvious that the figure needed strengthening, so the final dark outline was added using a fineliner pen, which brought her forward in the composition.

Sometimes a seemingly simple painting can use a variety of mixed media. In *Off to the Beach* (below), I used both inktense blocks and artbars, applying the colour before spraying water onto it. Once wet, I began tilting and moving the colours, which resulted in the luminosity in the water. Once dry, more artbar was added on top and finally a few spots of white acrylic paint were added using the handle of the brush. Acrylic was needed here as neither the artbars or Inktense would have achieved these lovely round blobs of pure white colour.

Without such experiments as these, I would not know which direction I could go in when using mixed media. Investing time to experiment and referring to the paintings that result is an important stage of development for any artist.

Off to the Beach
35.5 x 25.5cm (14 x 10in),
inktense blocks and artbars
on Not surface paper.

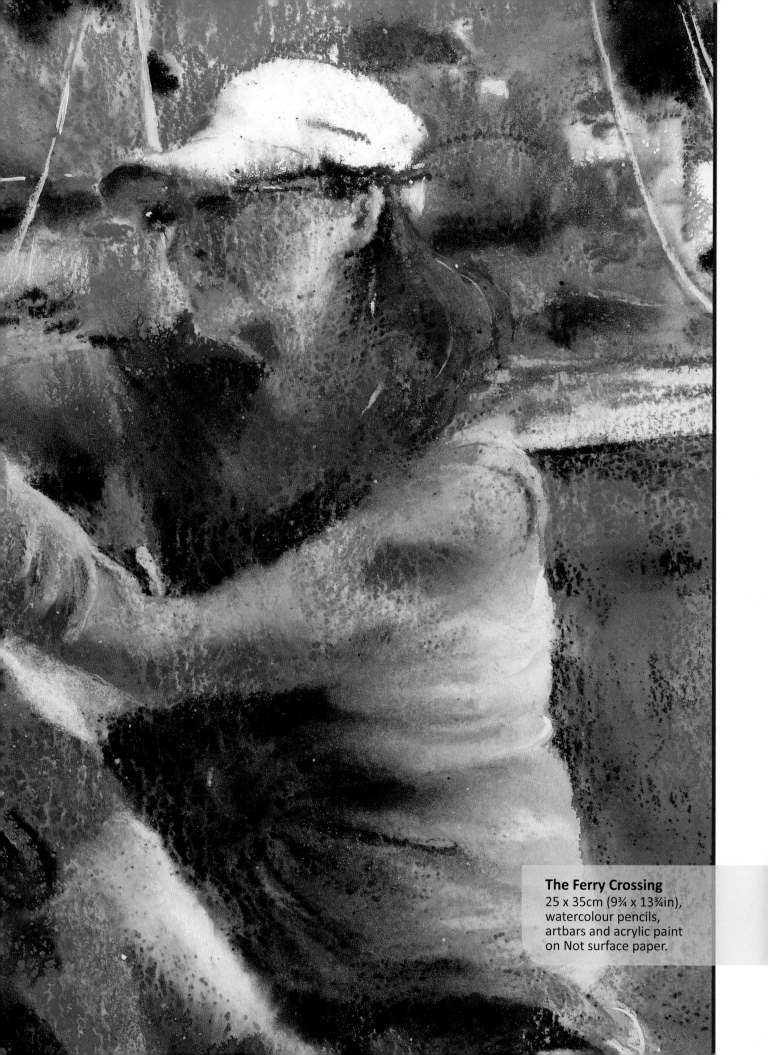

The Ferry Crossing
25 x 35cm (9¾ x 13¾in),
watercolour pencils,
artbars and acrylic paint
on Not surface paper.

I used both watercolour pencils and artbars to place the pigment in *The Ferry Crossing* (opposite) before spraying the painting with water and tilting the board. The interaction between these media and the water on the surface creates natural texture. I enjoy this lost and found technique but find that, once dry, I often need to add some details. A small amount of acrylic paint works well over these media.

Both *Sidmouth Seafront* and *The Little Blue Boat* (below) started as watercolour studies. Sometimes a painting using just one medium can be improved by adding another. It can seem a bit daunting, but sometimes taking risks is worthwhile.

I felt that the flat watercolour washes that made up each painting lacked texture, so a very solid layer of artbar was blocked in to cover the dry watercolour base where I felt additional texture was needed. Clean water was then sprayed over it and the board tilted to encourage the wet artbar pigment to move. Keeping the board at a tilt, any excess pigment ran off the painting through the dips of the paper, leaving areas of artbar remaining on top of the raised surface of the watercolour paper. I love the added dimension of the gritty textures, which I think add interest to an otherwise simple subject.

Using more than one medium in a painting can be a natural progression for an artist. The next step can be changing sections of our paintings or adding texture or depth by applying collage, which I explain and explore on the following pages.

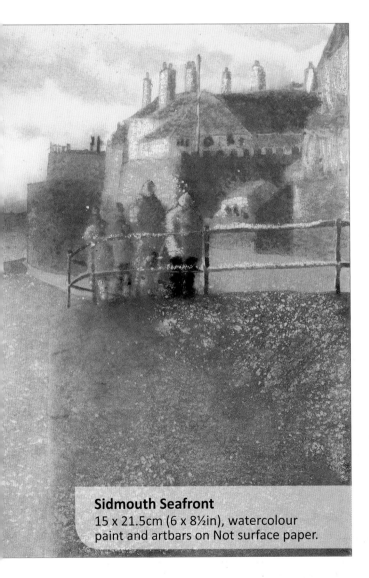

Sidmouth Seafront
15 x 21.5cm (6 x 8½in), watercolour paint and artbars on Not surface paper.

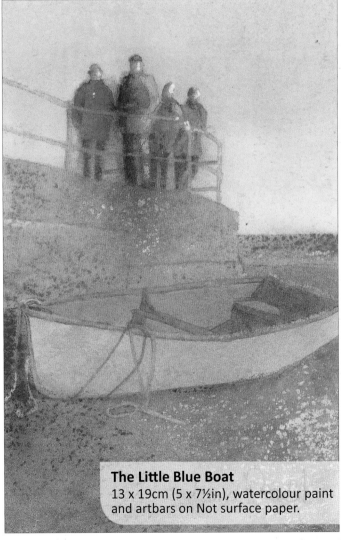

The Little Blue Boat
13 x 19cm (5 x 7½in), watercolour paint and artbars on Not surface paper.

Collage

Using collage can be a fun way to add another dimension to our work. Provided that it is not too thick, and it can be stuck to your paper, anything goes – newspaper, magazines, gift wrap, packaging materials, pressed flora, fibres and fabrics can all work. I use acrylic medium to stick my collage to paper. I avoid glue as I do not know how it will react with my art materials, whereas acrylic medium is safe and compatible, and I know I can work on top of it.

You can work on top of previous paintings which you are not pleased with, covering up unwanted sections and retaining the bits you like. Parts of previous paintings can also be cut up and used within another painting, providing inspiration for something else. I usually plan when I use collage, but you can also use it on a painting you were disappointed with, either by turning it upside down and using it as a coloured base for a new piece, or placing sections of cut-out magazine colours on top of your painting and seeing where it leads you next.

Experiment by placing a stencil – or stencils – on top of your painting and stipple complementary colours over the top of it.

I find a camera invaluable for collage work. As I experiment with pieces of collage I lay them on top of my work and from time to time photograph them. Once I begin moving things about and trying out ideas, I can never remember what I started with, so it is wonderful to be able to view my ideas as they progress. This is a simple way to get the best collage combination in your brainstorming session.

Tea Time
15 x 15cm (6 x 6in), artbar, inktense and collage on Not surface paper. A wash of soft mauve artbar was applied over the paper. Once dry I applied printed paper and cut-out collage sections, then drew the cup and saucer using a dark wash sketching pencil. Finishing touches in pink and white acrylic paint was applied over detail created with sprayed inktense, and stamped using artbars.

Birthday Tea
15 x 15cm (6 x 6in), artbar, inktense and collage on Not surface paper. This was built up using the same techniques as *Tea Time*, but using more vibrant colours.

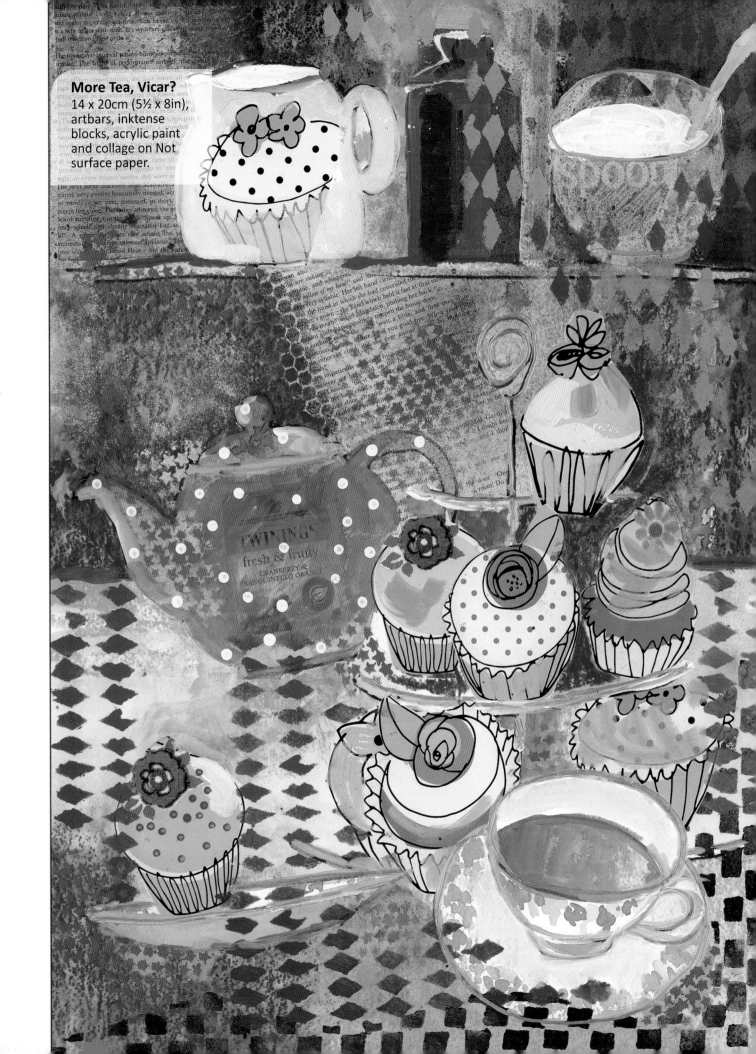

More Tea, Vicar?
14 x 20cm (5½ x 8in),
artbars, inktense
blocks, acrylic paint
and collage on Not
surface paper.

Tea Party

Once you begin to collect materials intended for collage work, you can adapt all sorts of pictures; even finished works you are not entirely happy with can be adjusted or even used as a base on which to use collage and stencils.

This project combines multiple water soluble media with collage work. There are many ideas here that you will be able to adapt in your own way using different combinations of your own colours.

YOU WILL NEED

Inktense blocks: dark aquamarine (1210), antique white (2300), deep violet (0760), fuchsia (0700), vivid green (1330), saddle brown (1740), baked earth (1800)

Artbars: duck egg blue (A31), topaz (A14), ultra blue (A12)

Not surface watercolour paper, 640gsm (300lb), 56 x 38cm (22 x 15in)

Tracing paper

Stencils: 30 x 30cm (11¾ x 11¾in) dots with edges mask, star pattern, diamond mesh

Small sponge

Stippler brush, large round brush, 12mm (½in) flat brush

Old newspapers and magazines

Water soluble gloss medium/varnish and old brush

Liquid acrylic paint in a fine-nozzled dispenser: gold, pink

Low-tack adhesive putty

Steel ruler and craft knife or scissors

Spray bottle

2B pencil

Masking tape and board

Kitchen paper and rubber gloves

1 With masking tape, attach the paper on to your board and make a border around it. Use a 2B pencil to draw out the basic shapes of the tea set.

2 Using the tracing paper and 2B pencil, make a tracing of the basic lines. This will be used as a reference later on, once the collage starts to cover the shapes.

3 Place the dots with edges mask stencil over the image, arranging it so the lacy edge appears as a doily underneath the plates as shown. If you do not have an appropriate stencil, you can use a large paper doily.

4 Moisten the sponge and rub it over both dark aquamarine and antique white inktense blocks to pick up a very light blue. Sponge it on over the edges of the stencil as shown. Use rubber gloves when using Inktense blocks with a stencil.

5 Carefully lift away the stencil, replace it on the lower left and sponge the same mix over this area to suggest a lacy tablecloth. Allow this area to dry fully before continuing with the painting.

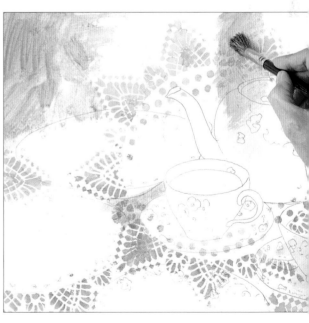

6 Make a small well of deep violet and antique white inktense blocks to make a lilac mix. Create marks and lines on the background using the stippling brush with loose, broad and sweeping strokes.

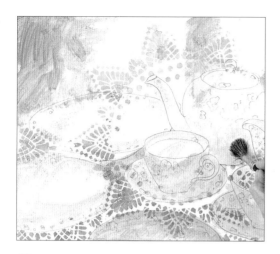

7 Make a pink mix in a small well from fuchsia and antique white inktense blocks. Use the stippling brush to colour the tea set loosely with the mix.

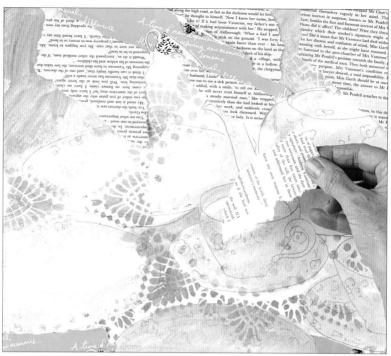

8 Tear out some sections of newsprint and turquoise parts of magazines. Place them on the surface and move them around, experimenting with the positioning until you are happy with their placement.

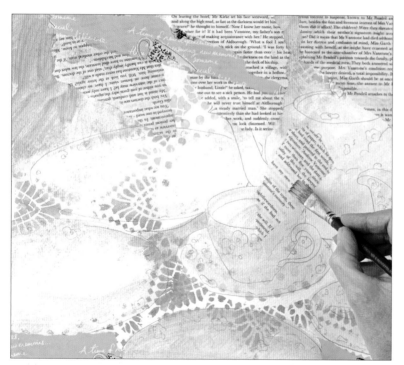

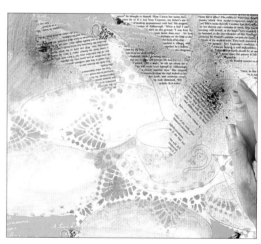

10 Once dry, make a very thick mix of deep violet 0760 inktense block, then transfer it into a spray bottle and dilute it. Use this to spritz the newsprint and background areas lightly. If it is too heavy or strong, lift it out a little with kitchen paper.

9 Use an old brush to paint water soluble gloss medium/varnish to the back of each piece and use this and the 12mm (½in) flat brush to glue them in place. Once placed, overlay the piece completely with the same gloss medium/varnish to secure them in place.

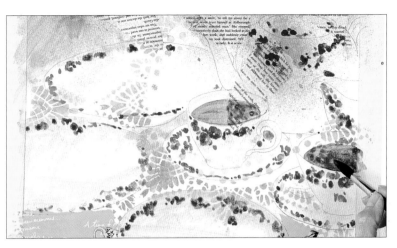

11 Allow to dry, then use a 2B pencil to redraw the lines of the tea set, using the tracing paper for reference if necessary.

12 Use the large round brush to suggest the flower designs on the tea set using the fuchsia and vivid green inktense blocks, then paint the tea in the cups with a mix of the saddle brown and baked earth inktense blocks and the large round brush.

13 Pick up colour from the fuchsia, deep violet and dark aquamarine inktense blocks on the same large round brush and block in shadow areas on the teapot, cups and saucers. Do not try and create a realistic effect; this stage is just to add some tonal interest on the right-hand side.

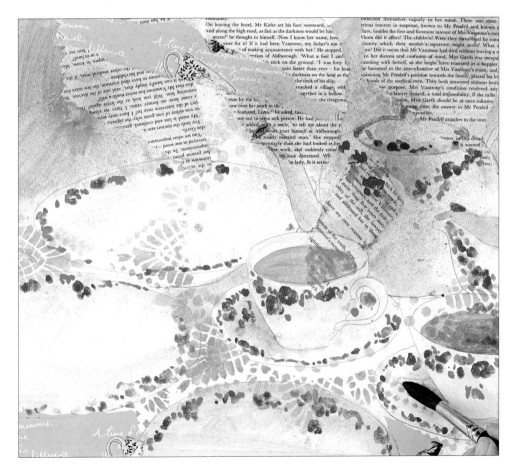

14 Once completely dry, pick up some colour from the duck egg blue artbar with a moist sponge. Place the star pattern stencil over the top left-hand side, then sponge over the area. Repeat over the central teacup.

15 Without cleaning the sponge, pick up some colour from the topaz artbars and sponge over a few other areas as shown. Next, again without washing out the sponge, pick up colour from the ultra blue artbar. Use the diamond mesh stencil to add some dark areas over the picture, concentrating on the background.

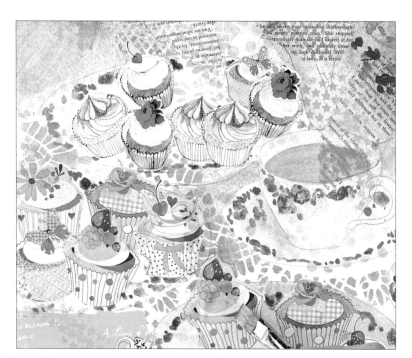

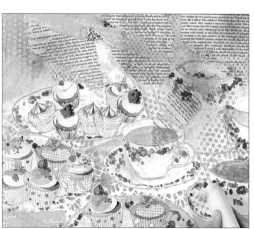

17 Use the dispenser to apply gold liquid acrylic paint around the edges of the tea set, leaving gaps for overlaps and where the cakes block your view. If you do not have a fine-nozzled dispenser, you can apply the gold paint with a fine brush.

16 Use a craft knife or scissors to cut out cupcakes from your magazines and secure them to the surface with water soluble gloss medium/varnish and the 12mm (½in) flat brush, then overlay them as a group with a little more to secure them more firmly.

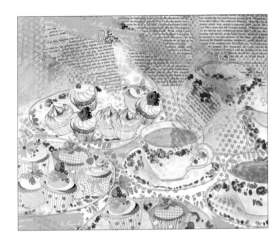

18 Add touches of gold in the centres of the flower decorations on the tea set and pink details on some of the cakes, the teapot and the background.

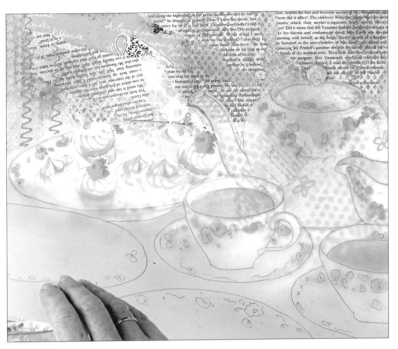

19 Use a craft knife or scissors to trim away the top of the background on the tracing paper mask, and place it over the picture using low-tack adhesive putty.

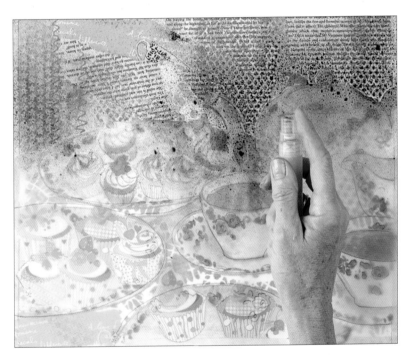

20 Use the spray bottle filled with diluted deep violet inktense block to spray the background lightly in order to add contrast between the background and foreground. Once the painting has dried, remove the tracing paper mask.

21 Use a steel ruler and the scalpel to carefully trim along the masking tape border to cut any overhanging collage shapes (see inset), being careful not to cut through the paper itself, then remove the masking tape to finish.

Garden Roses

You can adapt and use what ever materials you own for this project, so it does not matter if you do not have the exact materials used. In fact, this is part of the fun. Working with so many different media gives you the freedom to adapt any of the techniques explained in this book in order to make your painting truly unique.

I wanted to create a textural contrast between the freshly picked garden roses and the tea time setting and vase surrounding them. This is simply achieved by using different techniques and mixing media.

YOU WILL NEED

Not surface paper 300gsm (140lb)

Inktense pencils: fuchsia (0700), hot red (0410), iron green (1310), outliner (2400)

Artbars: vivid pink (A24), process magenta (A08), spearmint (A32), gooseberry (A33), tertiary green (A16), carnation (A07), opaque white (A72)

Inktense blocks: peacock blue (0820), sea blue (1200), red oxide (1910), fuchsia (0700), hot red (0410), iron green (1310), deep indigo (1100)

Large round brush

Pointer brush

Permanent masking medium

Colour shaper

Spray bottle

Scalpel

Cotton bud/swab

Scissors

2B pencil

Masking tape and board

1 Secure the paper to the board and run a border around it using masking tape. Draw out the basic shapes using a 2B pencil, then use the colour shaper to apply permanent masking medium to the flowers as shown.

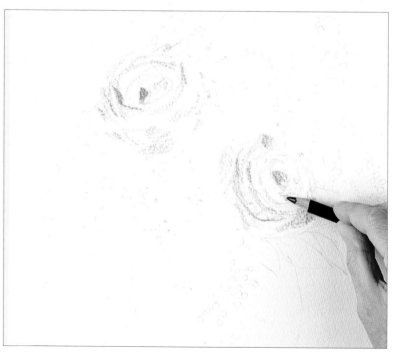

2 Use the fuchsia inktense pencil to establish the roses, using the point for darker areas and the flat for lighter, more textural parts.

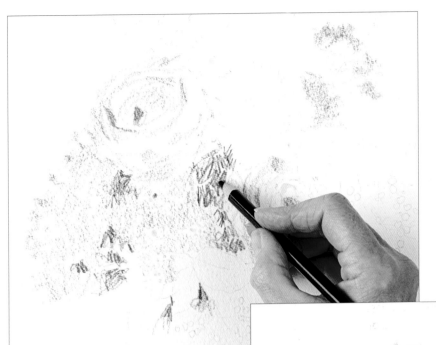

3 With the edge of the hot red inktense pencil, establish some under colour on the sprays of small flowers, then use a scribbling action to begin to suggest the background foliage with the iron green inktense pencil.

4 Establish the petals of the roses with vivid pink artbar, and use the process magenta artbar for the deeper inner petals. Add dots of vivid pink touches to the spray near the centre.

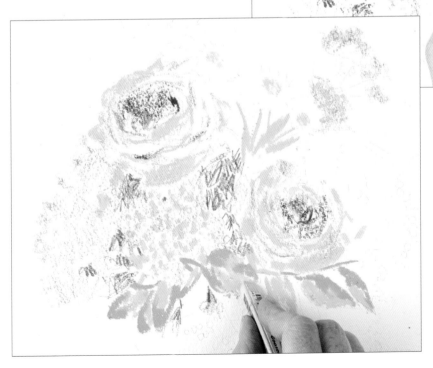

5 Use the spearmint and gooseberry artbars to suggest the larger leaves in the centre, and gooseberry alone for the daisy centres and light foliage in the sprays.

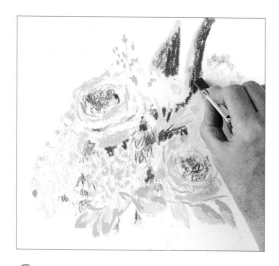

6 Use the gooseberry and spearmint artbars for the foliage at the upper centre, adding tertiary green for the darker areas of the large leaves.

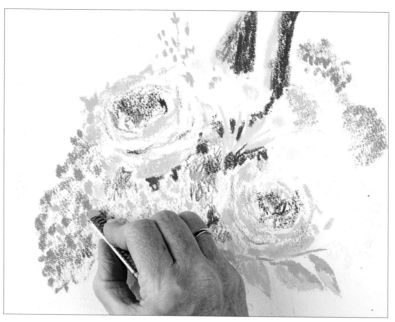

7 Develop the sprays on the sides with the carnation and spearmint artbars.

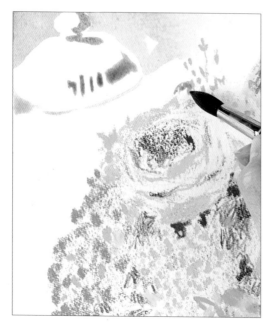

8 Create a well of dilute colour using the peacock blue inktense block. Use the large round brush to paint details on the pottery in the background. Dilute the paint further on the surface with clean water for a light suggestion of colour in the background.

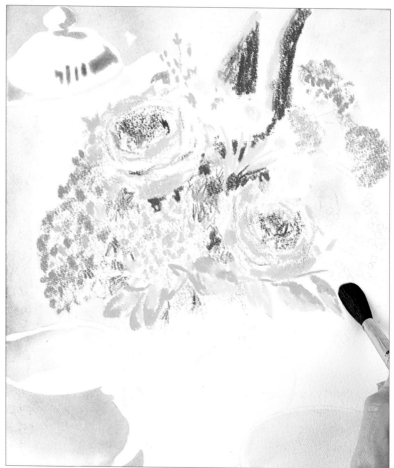

9 Continue to establish the background and pottery with this colour, varying the tone by adding more or less water on the paper.

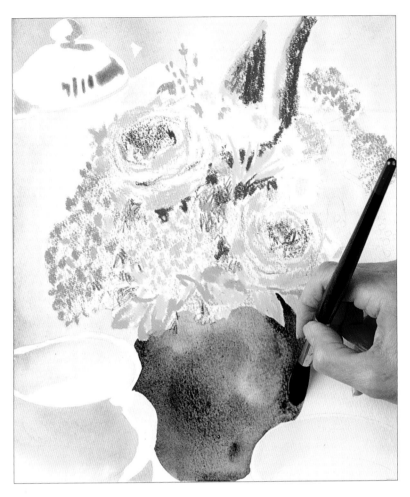

10 Pick up a stronger mix of peacock blue on the large round brush and paint in the main vase, fading the colour out to the top right-hand side. Working wet in wet, make a well of sea blue inktense block and pick up both peacock and sea blue on the same brush to paint the highlight area, before using the pure peacock blue mix for the shadow on the extreme top right.

11 Paint in the tea in the cup on the lower right-hand side using the large round and colour from the red oxide inktense block.

12 Complete the background using the peacock blue mix, diluting it heavily to get a subtle colour to suggest the edge of the teacup.

13 Use a spray bottle to lightly spray the bouquet with clean water and allow it to develop.

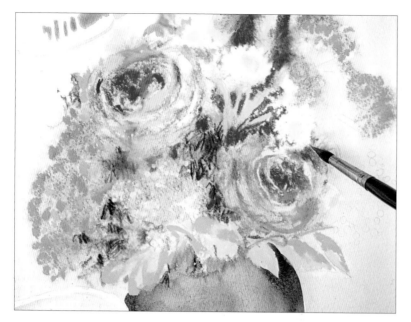

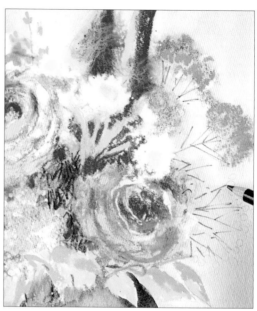

14 Wet the Pointer brush and use it to pick up some fuchsia inktense block on the end. Develop the roses with a few light touches, then rinse the brush and develop the foliage in the same way using the iron green inktense block, using a scribbling motion.

15 Use the inktense outliner pencil to establish stems on the right-hand side for the sprays and berries.

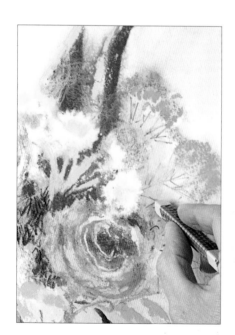

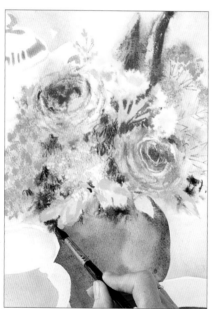

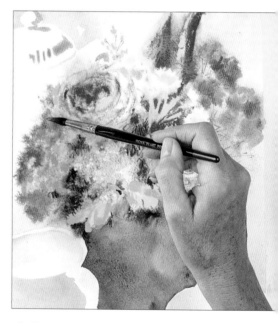

16 Use the spearmint artbars to add a soft effect to the right-hand side, and to add the centres to the daisies.

17 Protecting the rose with your hand, wet the leaves that overlay the vase with the spray bottle. Pick up a little of the iron green inktense block on the Pointer and develop the area.

18 Use the spray bottle to wet the flower sprays on the sides and add a little of the hot red inktense block using the Pointer brush. Leave the central spray slightly lighter pink.

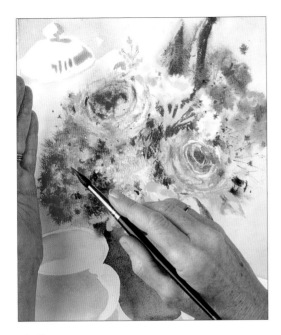

19 Pick up more colour from the hot red inktense block on the pointer brush, hold it over the sprays and tap the shaft sharply to spatter a little paint over the flower sprays.

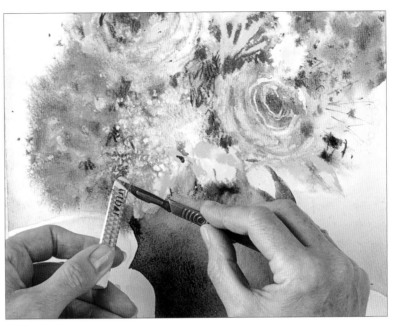

20 While the paper is still wet, use a scalpel to scrape a little of the gooseberry artbars on to the pink central flower spray.

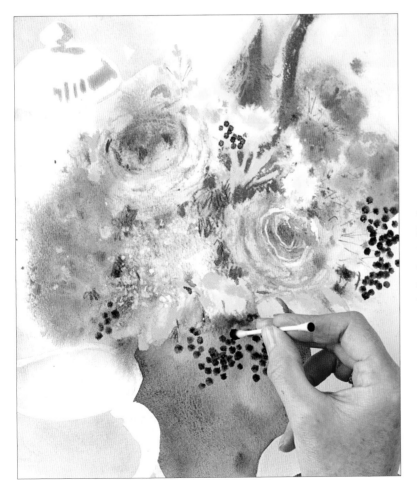

21 Wet a cotton bud/swab, tap off excess water, then rub it on to the deep indigo inktense block to pick up some colour. Dab this on to the surface to add berries to the ends of the stems made in step 15. Make sure some of them touch, and use a lighter touch to make some smaller berries for a more realistic effect.

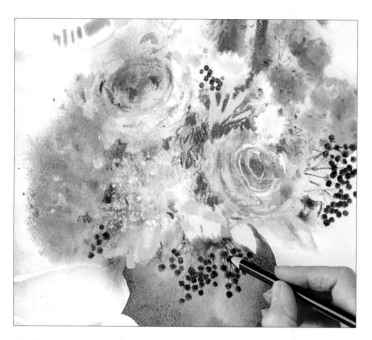

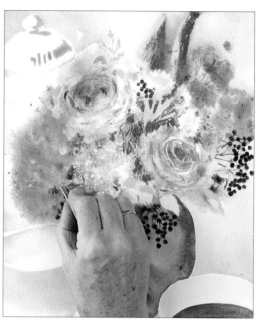

22 Use the iron green inktense pencil to join up a few of the new berries with stems.

23 Use the spearmint artbars to add a few highlights against the red areas.

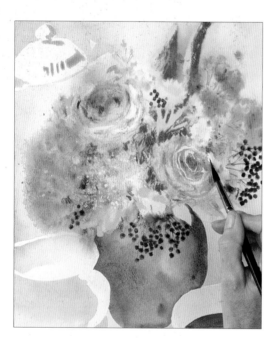

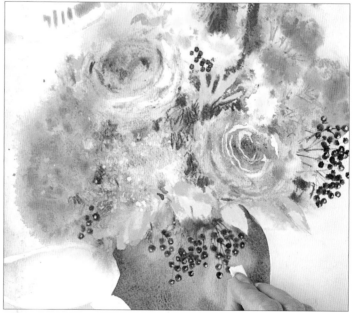

24 Dampen the pointer brush and gently rub away any inktense colour that is sitting over the permanent masking fluid to reestablish the highlights on the roses.

25 Allow the painting to dry, then use the opaque white artbar to add tiny highlights to the berries. Once dry, remove the masking tape to finish.

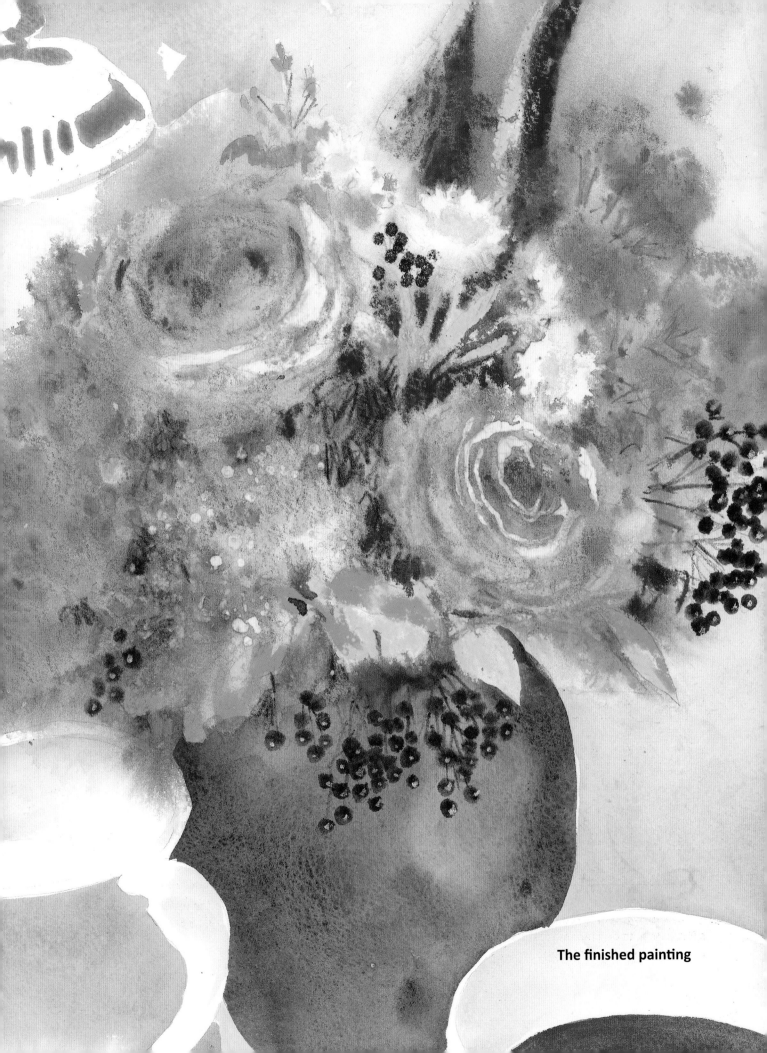

The finished painting

Conclusion

I believe that art is about painting what you want to paint, and enjoying the process. The whole point of being creative is to experience something new, to give yourself a different approach or viewpoint.

We can keep painting in the same way and, providing we are content, we will enjoy whatever we do. However, I am sure that all over the country there are people with art materials in cupboards, rarely – or perhaps never – used, which have the potential to create sumptuous texture and produce something different. All it needs is some confidence and the will to experiment and have a go.

This book is filled with the techniques and materials with which I have experimented over the years that excite me. I hope that it has helped you to step out of your comfort zone – whether you are picking up those water soluble materials for the first time or are simply looking for new approaches and inspiration.

Good luck with your painting. Your new creative discoveries will take you on a journey that you may wish you had started sooner, so start right now by getting those paints out!

Opposite
A Journey of Discovery
30.5 x 43cm (12 x 17in), watercolour pencils on Not surface paper. The subject was firmly blocked in using the sides of the pencils. A palette of the same colours used was scribbled on to a scrap piece of paper. Using a very wet round brush, the figures were wetted and, at the same time, the background was washed on from the paper palette, allowing sections to merge wet into wet. Once the painting had dried the shadow was painted on top. The wet into wet figures imply a mirage, but the shadows suggest otherwise.

Fields of Tuscany
33 x 23cm (13 x 9in), watercolour pencils, inktense pencils and blocks, and artbars on Not surface paper. This painting was produced in much the same way as the exercise on pages 20–23, using similar materials and techniques.

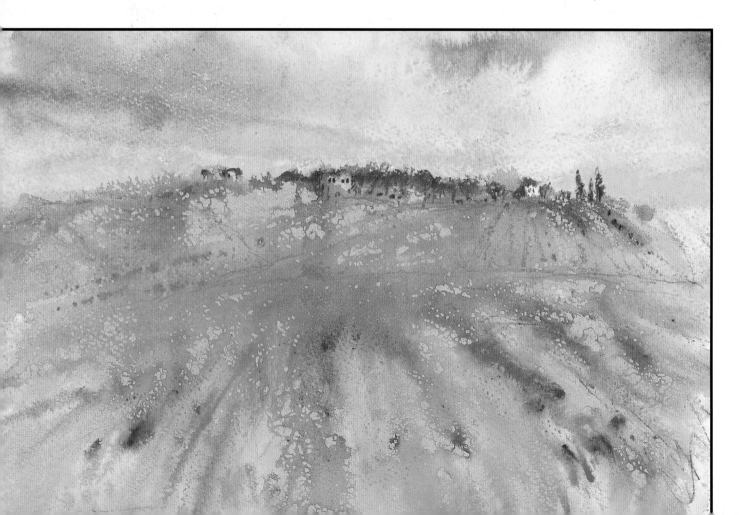

Index